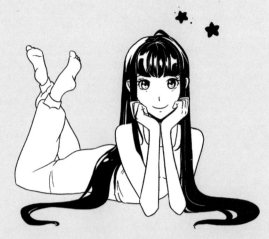

BEGINNER'S GUIDE TO
DRAWING
MANGA

BODIES AND POSES:
WORKBOOK FOR ASPIRING ILLUSTRATORS

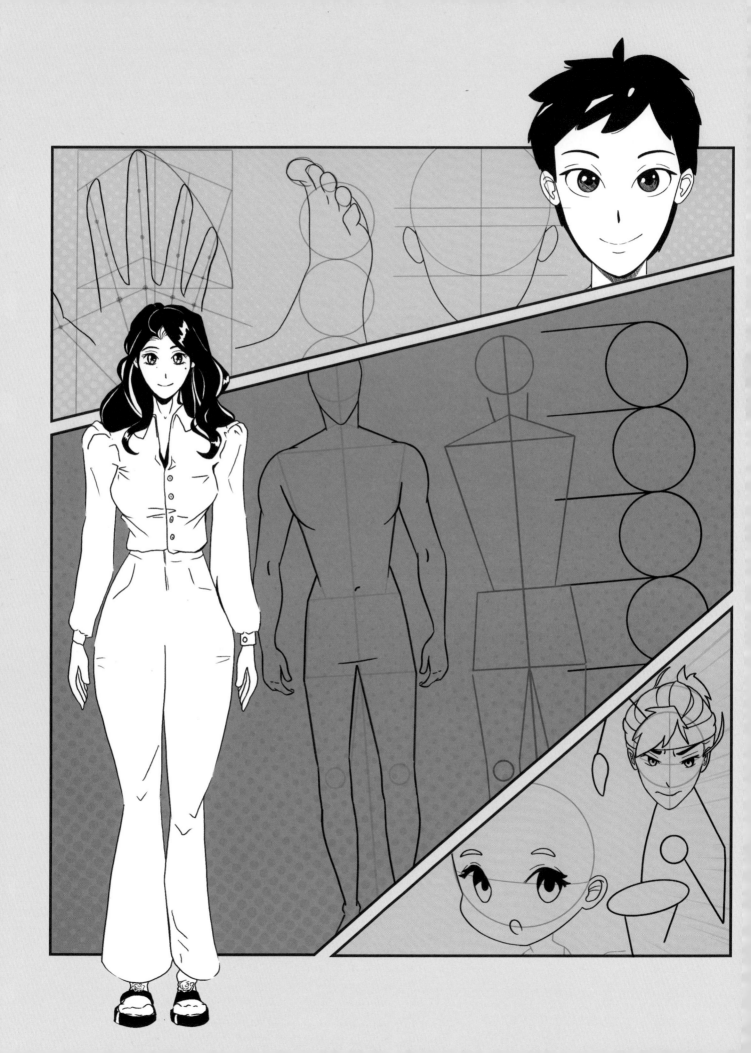

BEGINNER'S GUIDE TO
DRAWING MANGA

BODIES AND POSES:
WORKBOOK FOR ASPIRING ILLUSTRATORS

Céline Cresswell

DESIGN ORIGINALS
an Imprint of Fox Chapel Publishing
www.d-originals.com

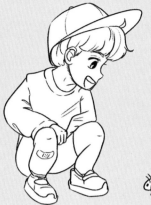

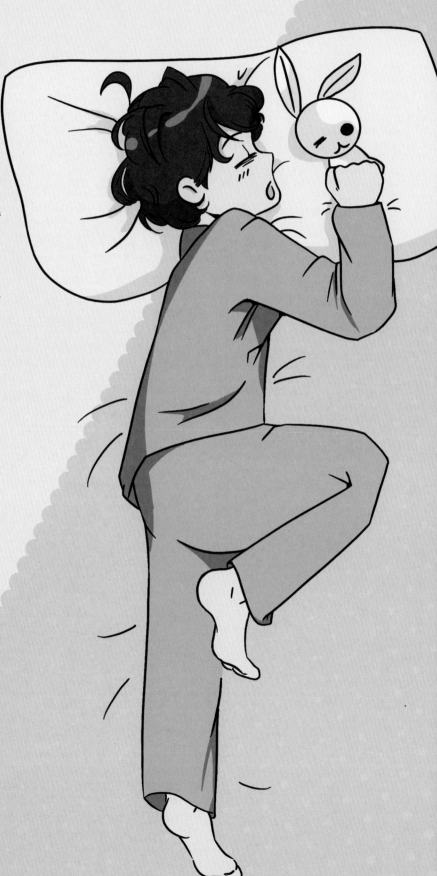

A QUARTO BOOK

ISBN: 978-1-4972-0683-0

This edition published in 2024 by New Design Originals Corporation, www.d-originals.com, an imprint of Fox Chapel Publishing, 800-457-9112, 903 Square Street, Mount Joy, PA 17552.

We are always looking for talented authors. To submit an idea, please send a brief inquiry to acquisitions@foxchapelpublishing.com.

Conceived, edited, and designed by
Quarto Publishing plc
1 Triptych Place
London SE1 9SH
www.quarto.com

QUAR.1173300

Assistant editor: Ella Whiting
Managing editor: Lesley Henderson
Designers: Joanna Bettles & Eliana Holder
Illustrator: Céline Cresswell
Art director: Martina Calvio
Publisher: Lorraine Dickey

Printed in China
First printing

Contents

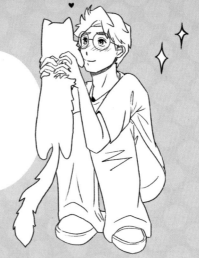

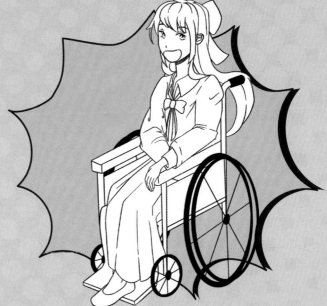

Find me on Instagram @redpanda_art
(I would love to see your drawings
from the book so feel free to tag or
share them with me!)

Meet Céline

Hi! I'm Céline and I'm an illustrator from
the UK.

I love to draw cute characters, and my first
attempt to learn began with a manga-style
book stuffed with scraps of paper covered
in manga characters. Over time, some
drawings slipped out and were lost, but
I still have the tutorial book with a couple of
drawings stashed under my bed!

I hope you can use this book to learn something new,
draw some awesome characters, and to look back in
the future to see how far you've come.

Enjoy this journey!

Céline Cresswell

Tools and Materials

You can create your manga characters with any tools, so pick whatever you feel most comfortable with. Here are some suggestions of what you might like to use.

PENCIL
Sketching the initial drawing in pencil is helpful in case you need to erase anything.

PENCIL SHARPENER

ERASER

PAPER
There is space to draw in the book, so you don't need extra paper. But if you want more space, grab any paper you have!

PEN
Traditionally, a black ink pen is used for drawing manga. You can use a pen for the entire drawing process or just at the end to finalize or emphasize the shapes.

About This Book

This book is a series of step-by-step tutorials paired with practice boxes that let you follow along in the book. The support provided matches your progression as you move through the chapters, with the earlier chapters containing the most guidance and the end chapters, the least.

The tutorials start by teaching you how to master body proportions, then how to draw specific parts of the body. Next, you'll put the previous chapters into practice by drawing full characters in various static poses, before exploring dynamic poses such as running. Try It Yourself gives you a chance to use all the skills from the book, since you'll copy example characters and create your own original characters!

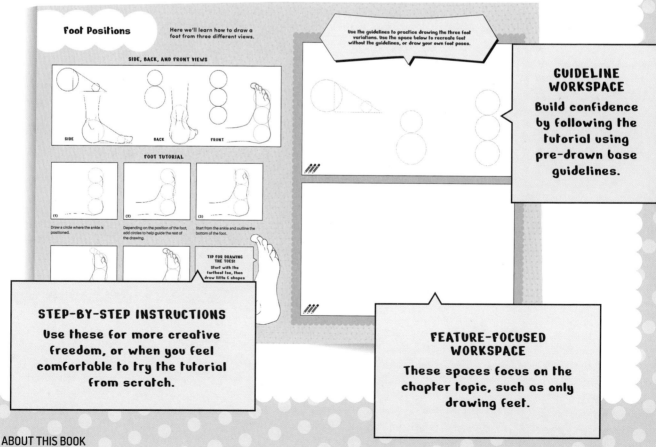

GUIDELINE WORKSPACE
Build confidence by following the tutorial using pre-drawn base guidelines.

STEP-BY-STEP INSTRUCTIONS
Use these for more creative freedom, or when you feel comfortable to try the tutorial from scratch.

FEATURE-FOCUSED WORKSPACE
These spaces focus on the chapter topic, such as only drawing feet.

EXAMPLE CHARACTERS
Later in the book there are some quick form tutorials to show you a number of different characters.

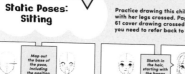

Static Poses: Sitting

Practice drawing this child sitting with her legs crossed. Pages 60–61 cover drawing crossed legs if you need to refer back to it.

Follow the tutorial in the space below.

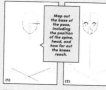

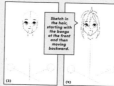

Map out the base of the pose, including the position of the spine, head, and how far out the knees reach.

Sketch in the hair, starting with the bangs at the front and then moving backward.

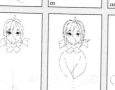

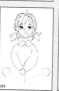

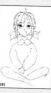

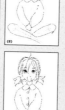

COMPLETED CHARACTERS
Test everything you've learned in the earlier chapters by copying completed characters in the workspaces and on the practice pages at the end of the book.

Put It All Together: Example Chibi Characters

Use these characters as references to practice drawing chibis in a variety of poses.

Use the space below to recreate any of the example chibi characters. Feel free to switch up any of the character design details or poses!

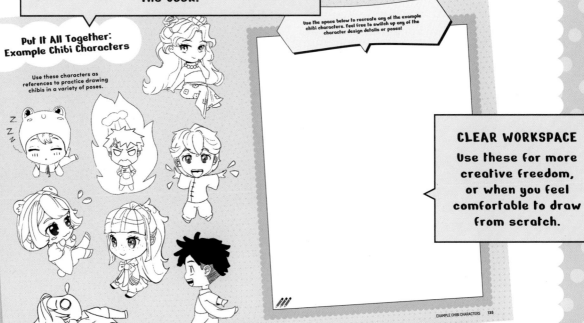

CLEAR WORKSPACE
Use these for more creative freedom, or when you feel comfortable to draw from scratch.

Figure Proportions

* - - - - - - - - - - *

This section teaches you how to proportion characters. First, we focus on different genders and ages, then we move on to body types. Note that these are characters generalized by their titles and that each can be drawn in a variety of ways.

The aim of this chapter is to become familiar with the basic shapes and sizes needed to draw a proportional character, so the body parts are simplified here. We will expand on this more in Chapter 2!

Adult Male Figure Proportions

Male anatomy is drawn using straight lines that tend to follow the basic shape guidelines shown here. The overall shape is quite blocky, but being an adult, there is more muscular development in this figure than in younger characters. This results in a triangular upper section and straight legs. Follow this tutorial to learn the generalized basic proportions of an adult male character.

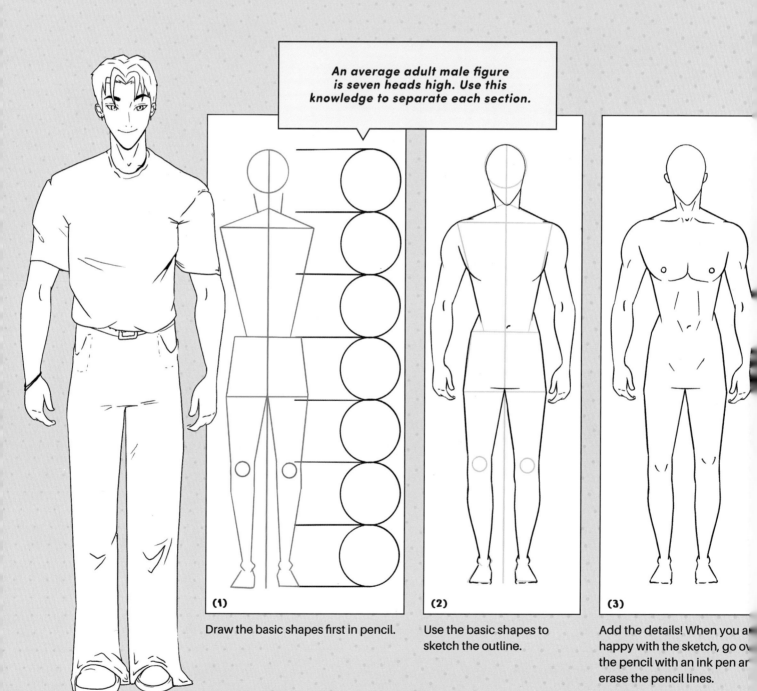

An average adult male figure is seven heads high. Use this knowledge to separate each section.

(1) Draw the basic shapes first in pencil.

(2) Use the basic shapes to sketch the outline.

(3) Add the details! When you are happy with the sketch, go over the pencil with an ink pen and erase the pencil lines.

Using the tutorial and the seven-head guidelines below, practice drawing the adult male body.

Start by drawing over these basic shapes, then use the empty space on the left to draw the body from scratch.

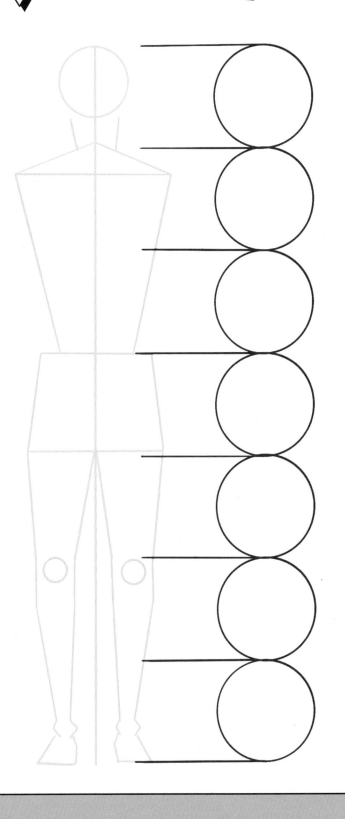

Adult Female Figure Proportions

Follow this tutorial to learn the generalized basic proportions of an adult female character. Female anatomy tends to have more curves and softer features. This means your outline is less rigid when following the basic shape guidelines. Differences you may notice between the male and female characters include the female body having narrower shoulders, and the shoulders having a similar width to the hips.

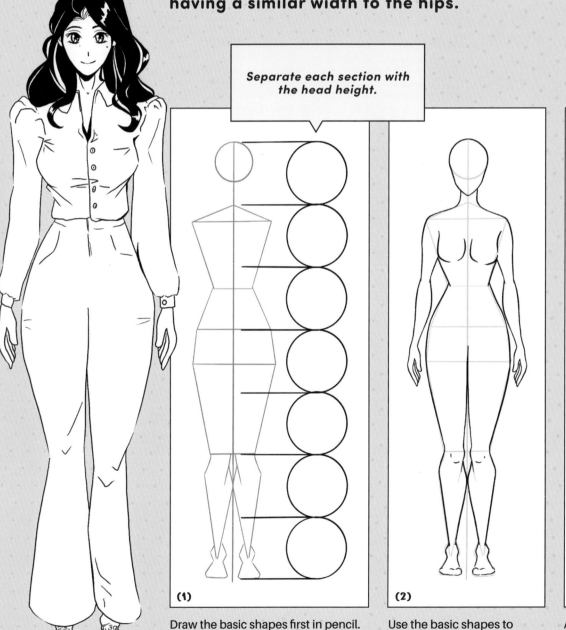

Separate each section with the head height.

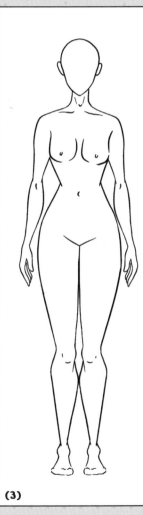

(1) Draw the basic shapes first in pencil.

(2) Use the basic shapes to sketch the outline.

(3) Add the details! When you a happy with the sketch, go ov the pencil with an ink pen ar erase the pencil lines.

Using the tutorial and the seven-head guidelines,
practice drawing the adult female body.

Start by drawing over the basic shapes, then use the
empty space on the left to draw the body from scratch.

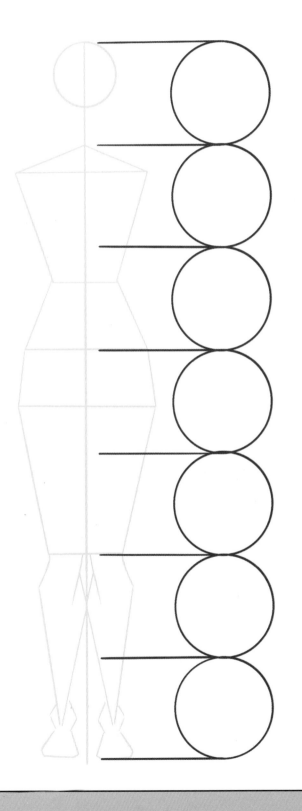

Teen Male Figure Proportions

Follow this tutorial to learn the basic proportions of a teen male character. The teen male body is very rectangular, still quite like the shape of the child's body. Two key changes include the shoulders beginning to extend outwards, becoming broader, and the height of the character increasing to approximately six-and-a-half heads tall.

> This teen male is slightly taller than the teen female, at six-and-a-half heads tall.

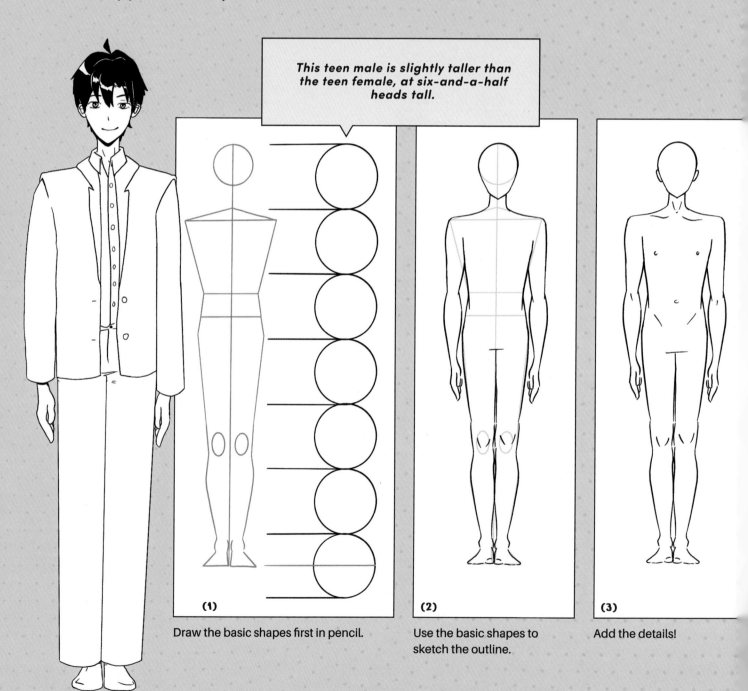

(1) Draw the basic shapes first in pencil.

(2) Use the basic shapes to sketch the outline.

(3) Add the details!

Using the tutorial and the guidelines using six-and-a-half heads, practice drawing the teen male body.

Start by drawing over these basic shapes, then use the empty space on the left to draw the body from scratch.

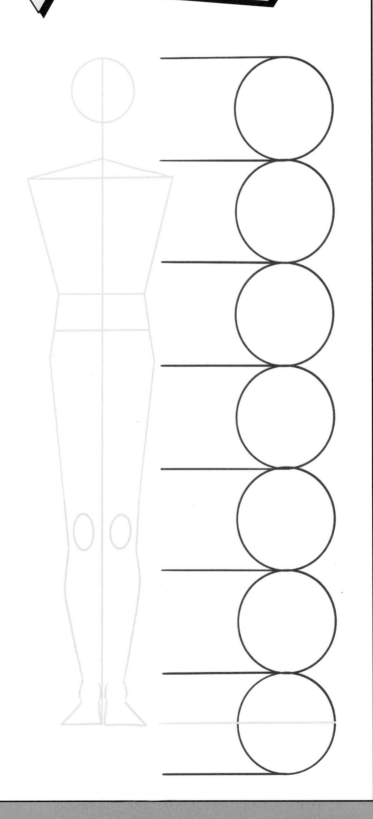

Teen Female Figure Proportions

Follow this tutorial to learn the basic proportions of a teen female character. When drawing teens, a hint of muscularity begins to appear, moving from a very rectangular child's body to having slight divots and curves. If you've tried either of the adult tutorials, it feels like a less exaggerated version of those. You still have the curves of the adult female here, but they are slighter.

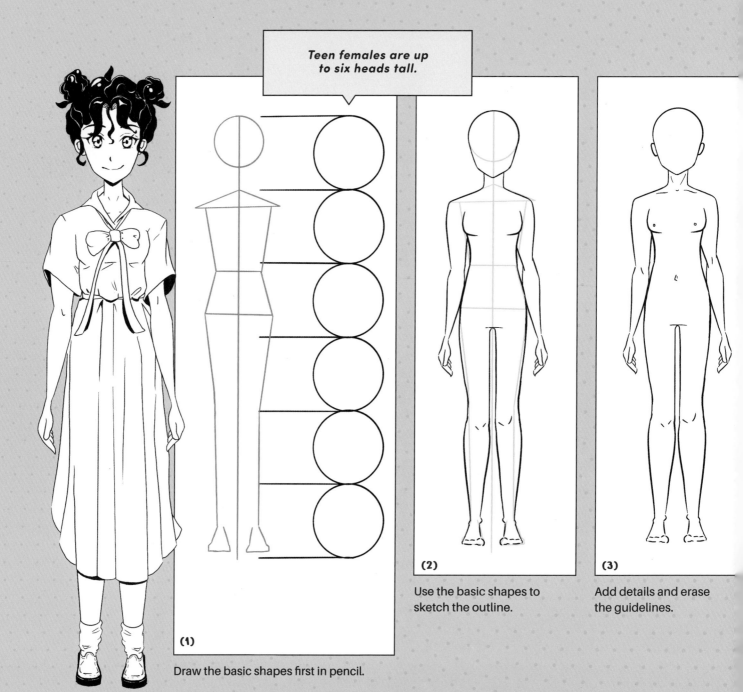

Teen females are up to six heads tall.

(1) Draw the basic shapes first in pencil.

(2) Use the basic shapes to sketch the outline.

(3) Add details and erase the guidelines.

Using the tutorial and the six-head guidelines, practice drawing the teen female body.

Start by drawing over these basic shapes, then use the empty space on the left to draw the body from scratch.

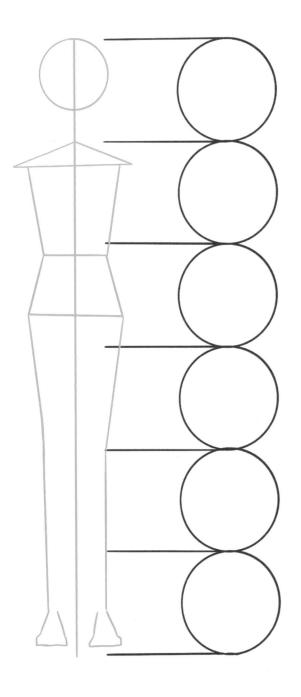

Child Figure Proportions

Follow this tutorial to learn the basic proportions of a generalized child character. Child anatomy is the simplest of the figure proportions covered in this book. Their basic shape is small—approximately four heads tall—and rectangular. This tutorial can be used for all child characters.

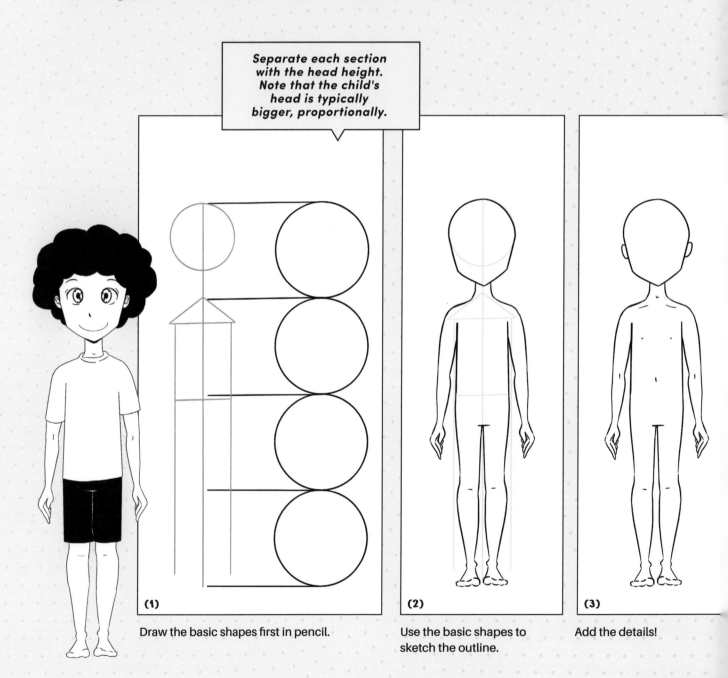

Separate each section with the head height. Note that the child's head is typically bigger, proportionally.

(1) Draw the basic shapes first in pencil.

(2) Use the basic shapes to sketch the outline.

(3) Add the details!

Using the tutorial and the four-head guidelines, practice drawing a child-proportioned body.

Start by drawing over these basic shapes, then use the empty space on the left to draw the body from scratch.

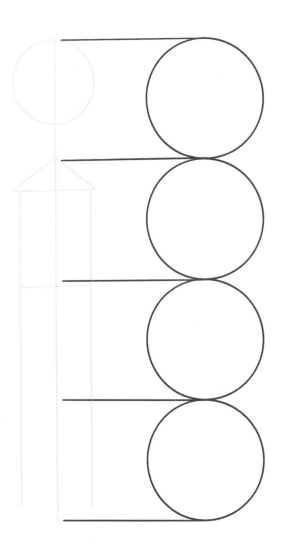

Senior Male Figure Proportions

Follow this tutorial to learn the basic proportions of a senior male character. Proportions of elderly characters are like the proportions of adult characters, but with slight adjustments to the head and outline. This tutorial will use the basic shapes from the adult tutorials and add the variations of the senior characters in the outline. Don't worry, I'll point out where things have changed!

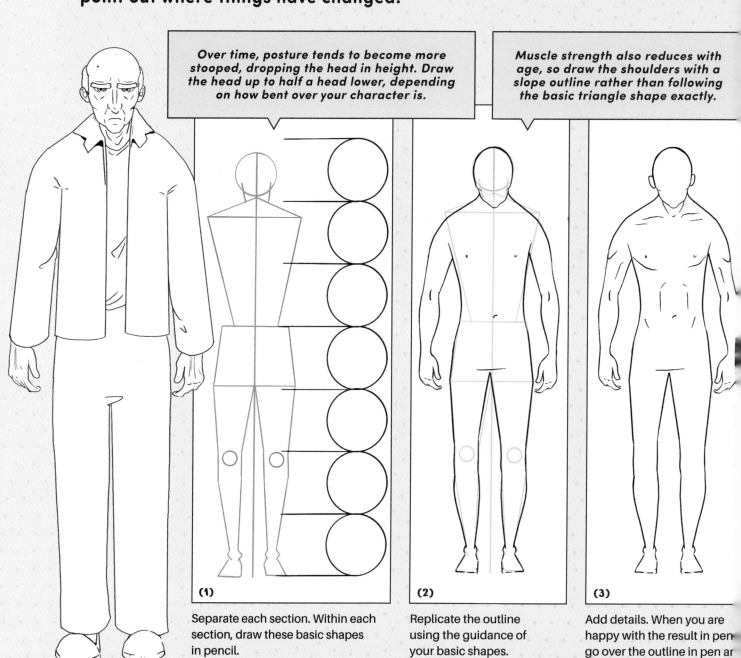

Over time, posture tends to become more stooped, dropping the head in height. Draw the head up to half a head lower, depending on how bent over your character is.

Muscle strength also reduces with age, so draw the shoulders with a slope outline rather than following the basic triangle shape exactly.

(1)
Separate each section. Within each section, draw these basic shapes in pencil.

(2)
Replicate the outline using the guidance of your basic shapes.

(3)
Add details. When you are happy with the result in pen, go over the outline in pen and erase your pencil lines.

Using the tutorial and the seven-head guidelines, practice drawing the senior male body.

Start by drawing over these basic shapes, then use the empty space on the left to draw the body from scratch.

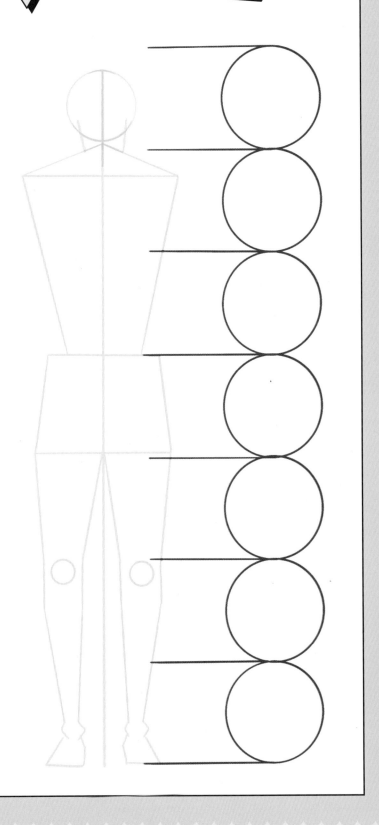

Senior Female Figure Proportions

Follow this tutorial to learn the basic proportions of a senior female character. As seen in the senior male tutorial, the overall proportions of a senior female character are comparable to the adult female's body, with some slight adjustments. Let's use the basic shapes of the adult female and observe where the outlines vary.

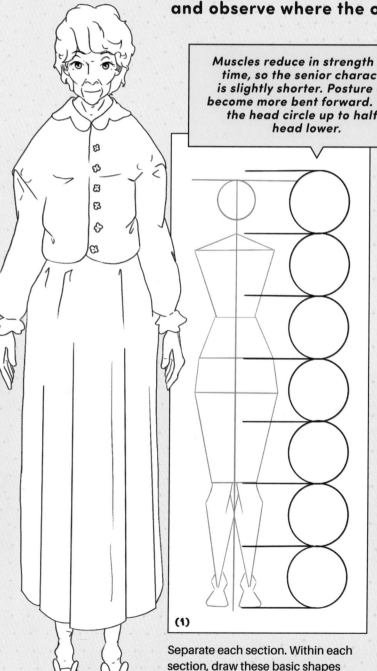

> Muscles reduce in strength over time, so the senior character is slightly shorter. Posture can become more bent forward. Draw the head circle up to half a head lower.

> The character's muscles relax and the skin stretches. Show this by drawing a more "relaxed" outline around the basic shapes, letting the shoulders drop and the outline overextend.

(1) Separate each section. Within each section, draw these basic shapes in pencil.

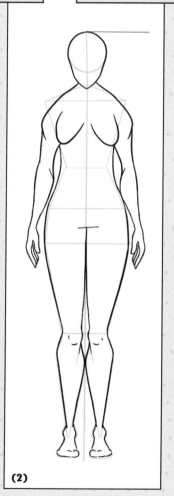

(2) Use the basic shapes to draw your outline.

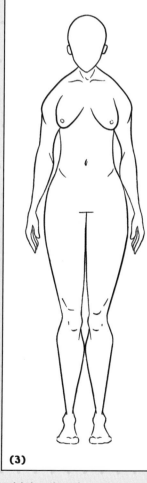

(3) Add details. When you are happy with the result, go over the outline in pen and erase your pencil lines.

Using the tutorial and the seven-head guidelines, practice drawing a senior female figure.

Start by drawing over these basic shapes, then use the empty space on the left to draw the body from scratch.

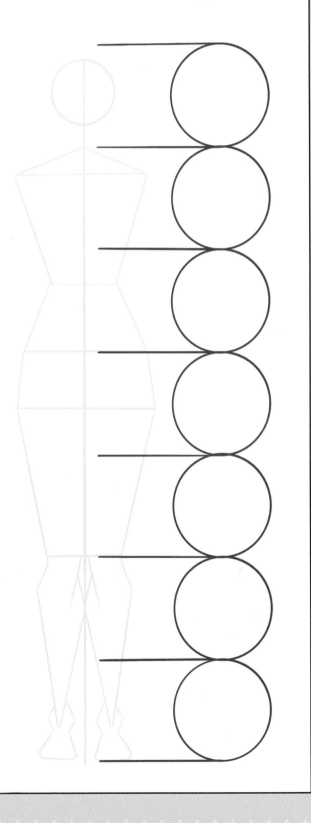

Muscular Male Figure Proportions

These next tutorials build on the basic proportions established for adults and children, with generalized variations of body types. Follow this tutorial to draw a muscular (also known as mesomorphic) male character. Here we adapt the adult male basic shapes outlined on page 12.

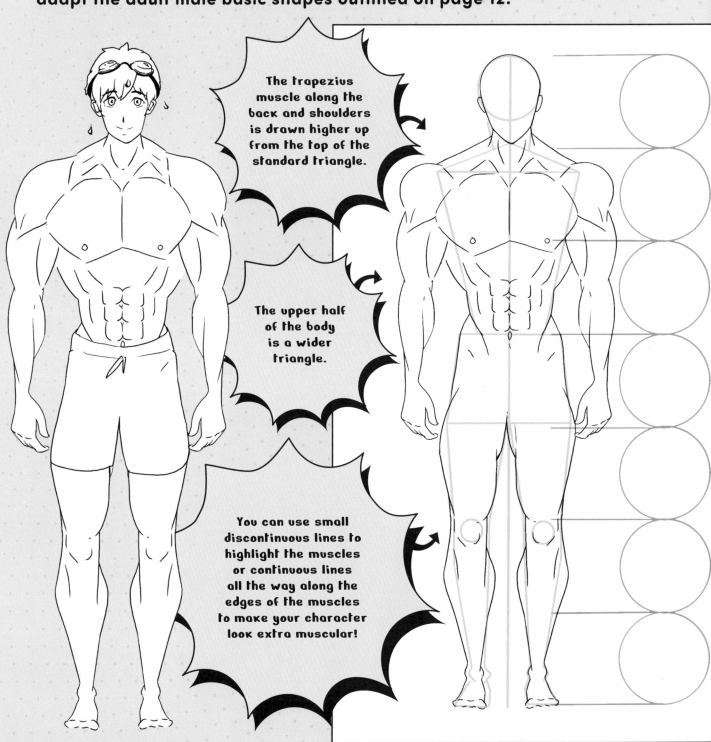

The trapezius muscle along the back and shoulders is drawn higher up from the top of the standard triangle.

The upper half of the body is a wider triangle.

You can use small discontinuous lines to highlight the muscles or continuous lines all the way along the edges of the muscles to make your character look extra muscular!

Using the tutorial and the seven-head guidelines, practice drawing the muscular male body.

Start by drawing over these basic shapes, then use the empty space on the left to draw the body from scratch.

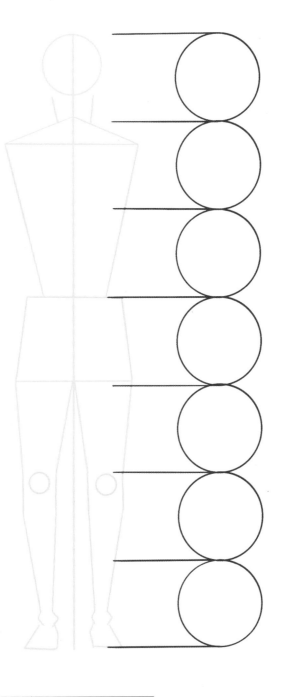

A good trick for drawing very muscular characters is to look up images of body builders. Their muscles are clearer to see because of the tanning they often use. This will help you decide where to draw the little lines that define the muscles and learn where the muscles are in general so you can create more anatomically accurate drawings.

Muscular Female Figure Proportions

Follow this tutorial to draw a muscular female character. This body type uses the adult female basic shapes. Refer to page 14 for the adult female tutorial.

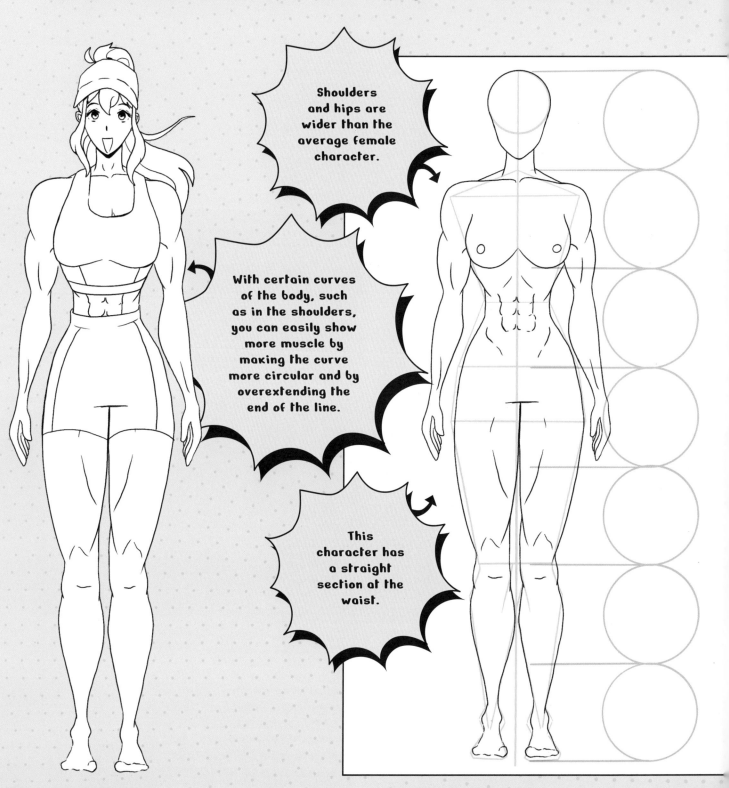

Shoulders and hips are wider than the average female character.

With certain curves of the body, such as in the shoulders, you can easily show more muscle by making the curve more circular and by overextending the end of the line.

This character has a straight section at the waist.

Using the tutorial and the seven-head guidelines, practice drawing this muscular female character.

Start by drawing over these basic shapes, then use the empty space on the left to draw the body from scratch.

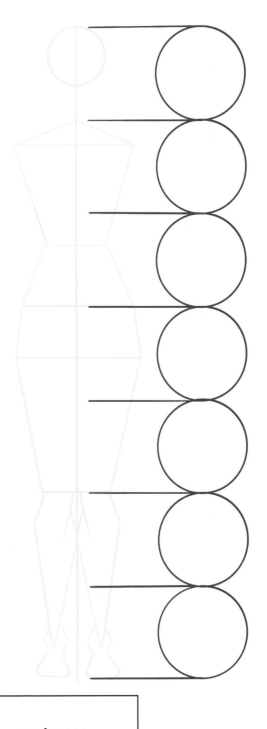

As with the muscular male character, you can look up images of bodybuilding women to really see ALL of the muscles. This is helpful if you want to create a character who is even more muscular than the one shown here!

Lean Male Figure Proportions

Follow this tutorial to draw a lean (also known as ectomorphic) male character. Lean body types have less-prominent muscle. Here we use the adult male basic shapes outlined on page 12.

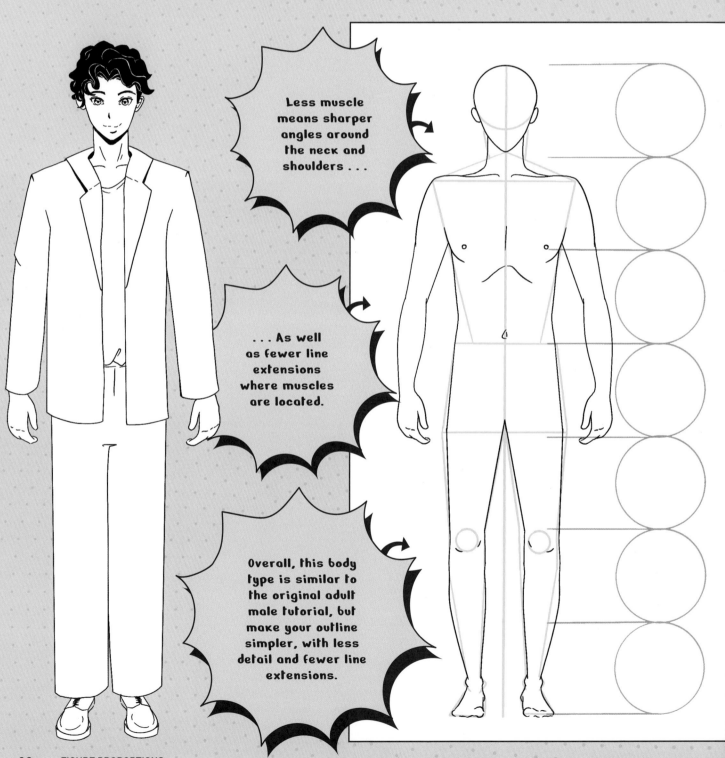

Less muscle means sharper angles around the neck and shoulders . . .

. . . As well as fewer line extensions where muscles are located.

Overall, this body type is similar to the original adult male tutorial, but make your outline simpler, with less detail and fewer line extensions.

Using the tutorial and the seven-head guidelines, practice drawing a lean male character.

Start by drawing over these basic shapes, then use the empty space on the left to draw the body from scratch.

Lean Female Figure Proportions

Follow this tutorial to draw a lean female character. This body type adapts the adult female basic shapes outlined on page 14.

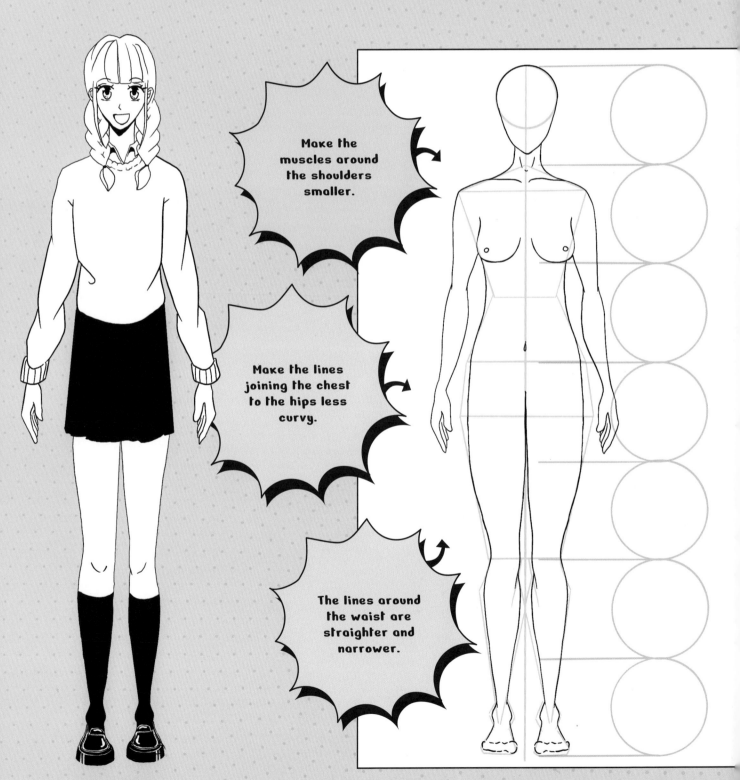

Make the muscles around the shoulders smaller.

Make the lines joining the chest to the hips less curvy.

The lines around the waist are straighter and narrower.

Using the tutorial and the seven-head guidelines, practice drawing a lean female character.

Start by drawing over these basic shapes, then use the empty space on the left to draw the body from scratch.

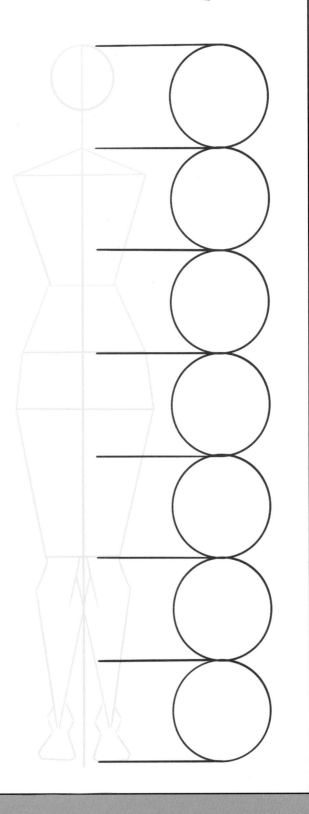

Curvy Male Figure Proportions

Follow this tutorial to draw a curvy (also known as endomorphic) male character. Here we use the adult male basic shapes. For a reminder of the adult male tutorial, refer to page 12.

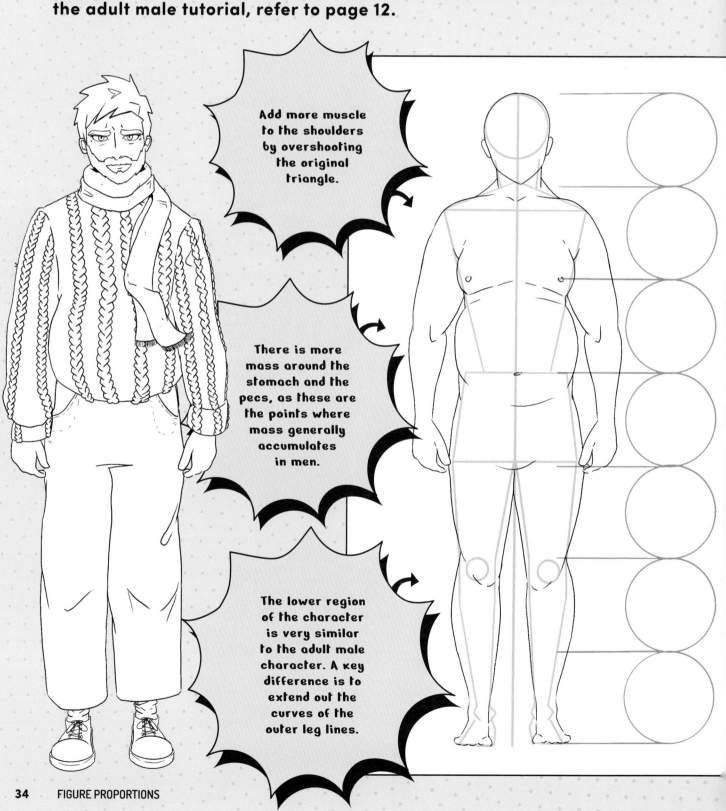

Add more muscle to the shoulders by overshooting the original triangle.

There is more mass around the stomach and the pecs, as these are the points where mass generally accumulates in men.

The lower region of the character is very similar to the adult male character. A key difference is to extend out the curves of the outer leg lines.

Using the tutorial and the seven-head guidelines, practice drawing this curvy male character.

Start by drawing over these basic shapes, then use the empty space on the left to draw the body from scratch.

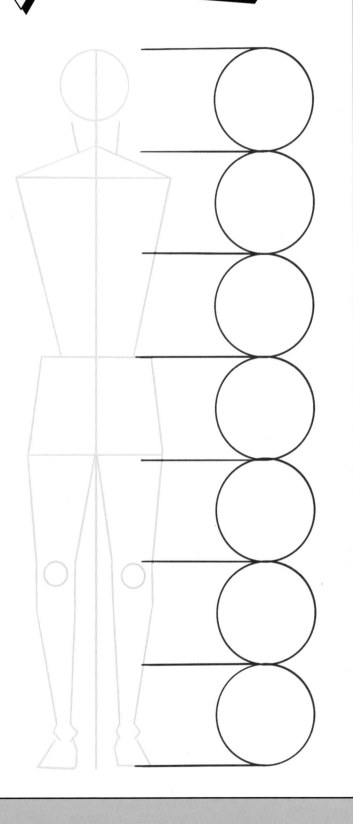

Curvy Female Figure Proportions

Follow this tutorial to draw a curvy female character. Here, we adapt the adult female basic shapes outlined on page 14.

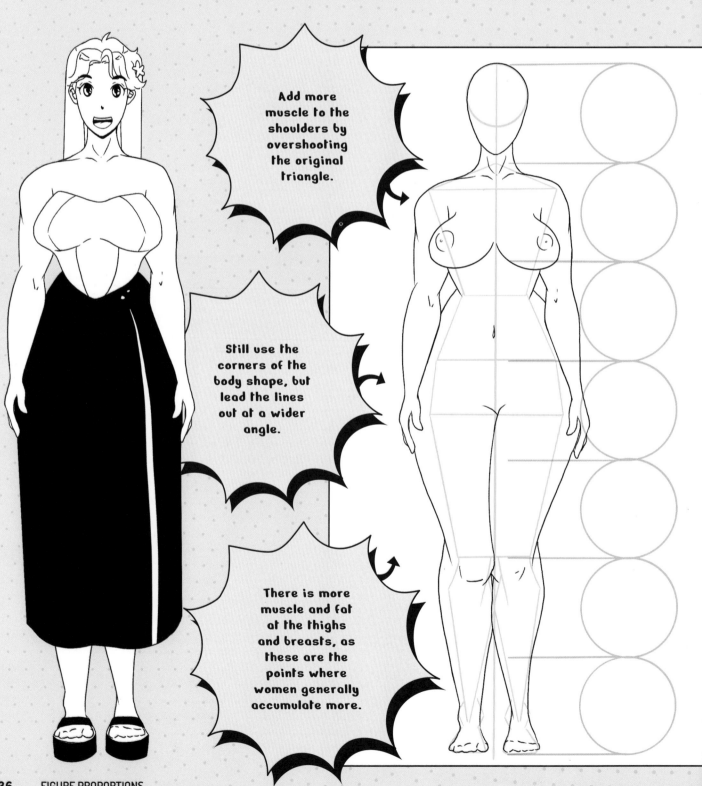

Add more muscle to the shoulders by overshooting the original triangle.

Still use the corners of the body shape, but lead the lines out at a wider angle.

There is more muscle and fat at the thighs and breasts, as these are the points where women generally accumulate more.

Using the tutorial and the seven-head guidelines, practice drawing the curvy female character.

Start by drawing over these basic shapes, then use the empty space on the left to draw the body from scratch.

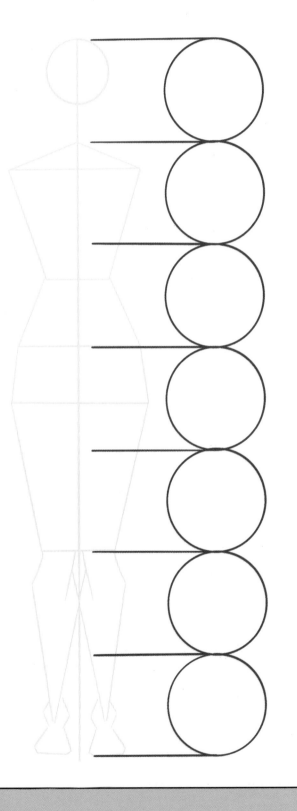

Chibi Proportions

Chibis have childlike proportions and wide eyes. While always short, they can range in heights of "chibi heads." Typically, they are one-and-a-half to three "chibi heads" tall, with heads that are very large in proportion to their bodies.

For this 2-head chibi, body length = head size.

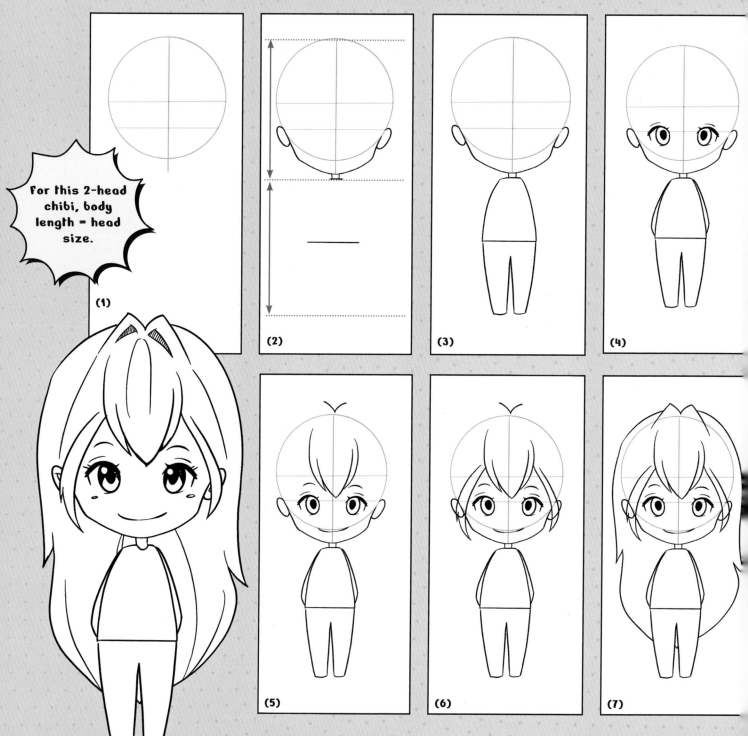

(1)

(2)

(3)

(4)

(5)

(6)

(7)

Follow the tutorial for this chibi figure
using the guidelines below, then try on
your own in the next box.

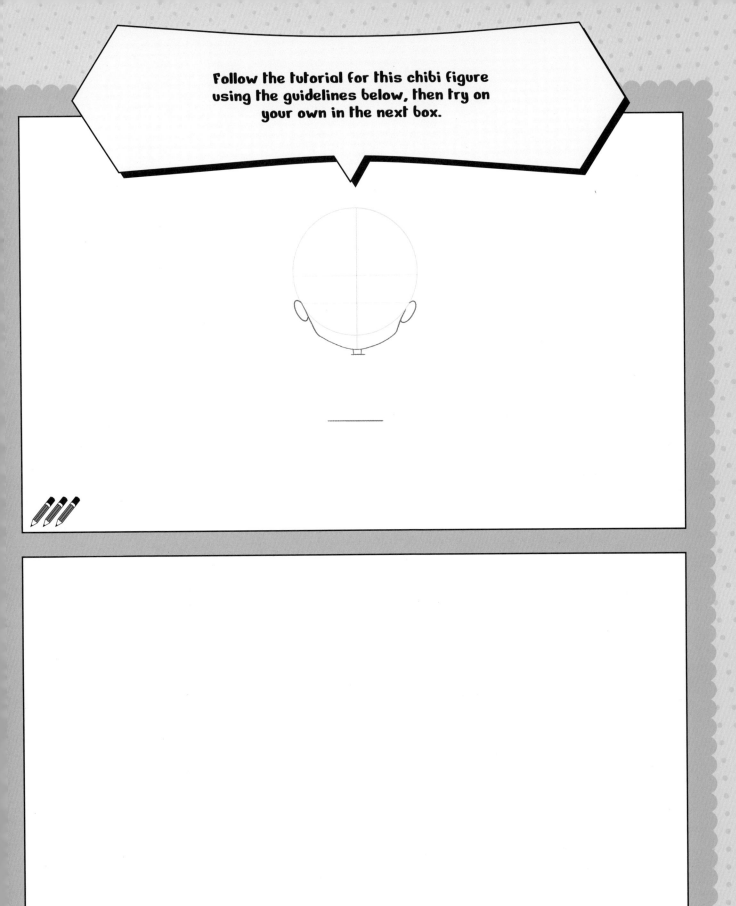

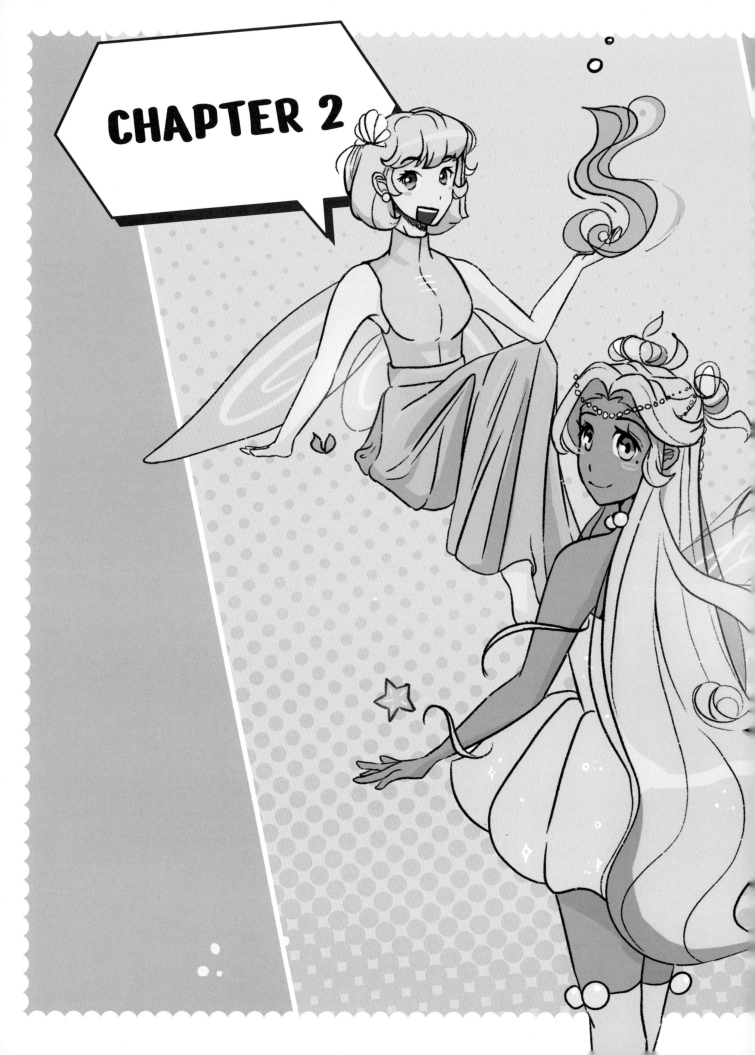

CHAPTER 2

Drawing the Body

✳ – – – – – – – – – – ✳

Nothing is better than feeling confident enough to draw any pose you like! However, you might sometimes feel a little daunted by the hand position or the angle of the feet in a reference image.

Use this chapter to learn how to draw hands, feet, faces, and more. It's common to feel nervous about drawing certain parts of the body, so use the tutorials to face those fears with guided help and practice.

Hand Proportions

This tutorial makes drawing hands easier by breaking down the proportions and shapes of the hand in a simple position.

(1)

Draw a rectangle with a height twice its width. Halve the rectangle vertically and horizontally.

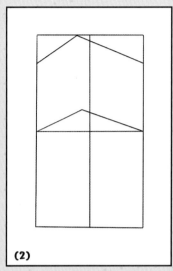

(2)

Draw an asymmetrical triangle at the center line. Replicate the triangle at the top of the rectangle.

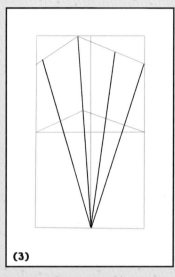

(3)

From the base center, draw four lines fanning out, using the two triangles to guide you.

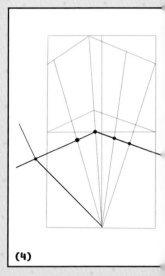

(4)

Add a third asymmetrical triangle.

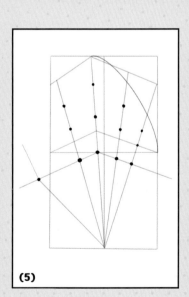

(5)

Section each of the finger lines into thirds, using dots. These are the finger joints.

The squishy side of the fingertip is curved.

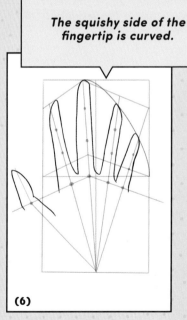

(6)

Outline the fingers. Draw circles at each joint, getting smaller toward the fingertips if it helps to get the finger width correct.

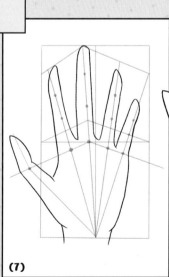

(7)

Outline the thumb. Remember to curve the squishy side of the thumb!

Finish with line art, erase any rough lines, and add some simple hand creases.

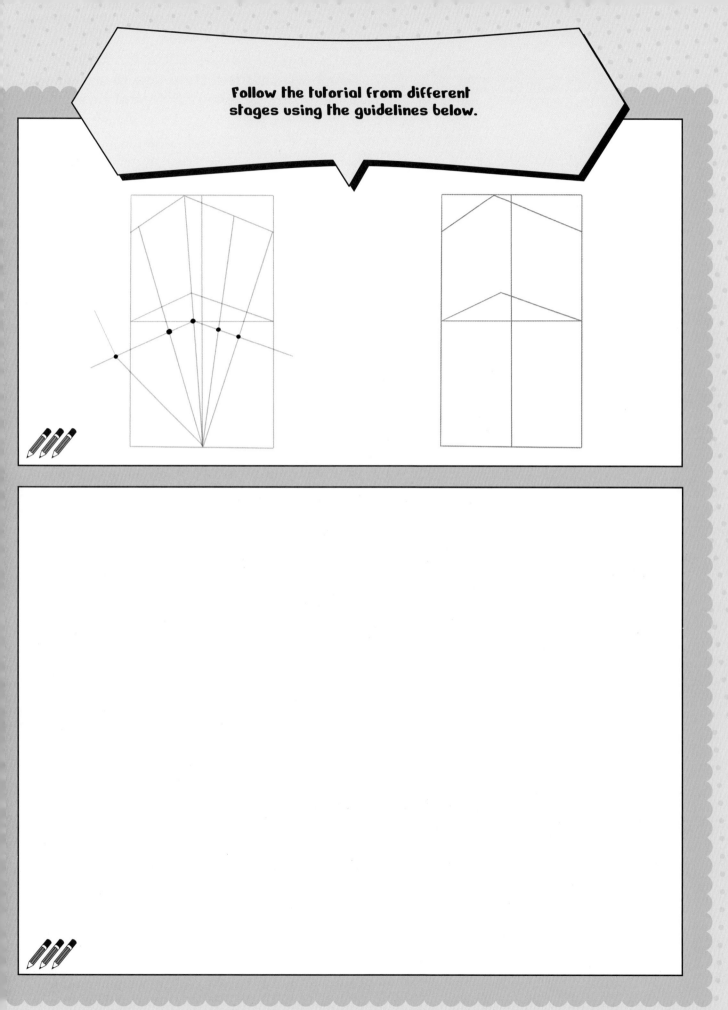

Follow the tutorial from different stages using the guidelines below.

Hand Positions

Let's look at how to draw hands in any position. This will help you to draw characters in many different poses.

SIMPLE HAND SEGMENTATION

When you are comfortable with the curves and shapes of the hand, you won't always need to draw all the original guidelines.

This illustration shows how to simply segment the parts of the hand for drawing a variety of positions.

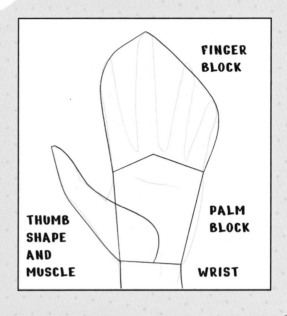

FINGER BLOCK

THUMB SHAPE AND MUSCLE

PALM BLOCK

WRIST

HAND TUTORIAL

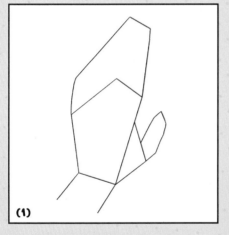

(1)

Break the hand down into the four basic segments.

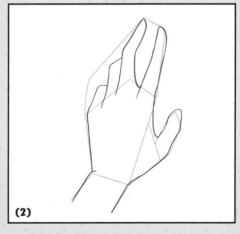

(2)

Draw each section of the hand into each segment.

Go over the hand with an ink pen, add details such as hand creases, and erase the lines.

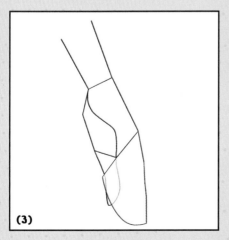

(3)

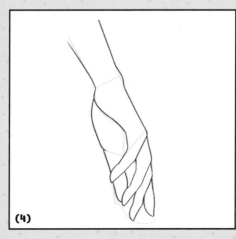

(4)

Follow the tutorials to draw the two example hand positions. You can also use the space below to practice drawing hands at other angles.

For this, I recommend drawing a hand from real life. It also helps to do the sketch and then take a break before doing the final ink. By coming back to it later, you'll be able to see where things are a little "off," which it makes it easier to correct.

Foot Positions

Here we'll learn how to draw a foot from three different views.

SIDE, BACK, AND FRONT VIEWS

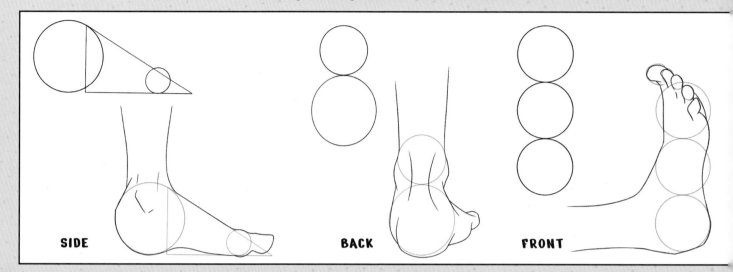

SIDE BACK FRONT

FOOT TUTORIAL

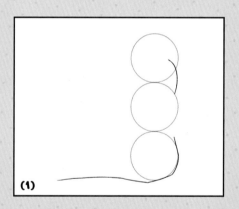

(1)

Draw a circle where the ankle is positioned.

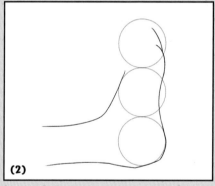

(2)

Depending on the position of the foot, add circles to help guide the rest of the drawing.

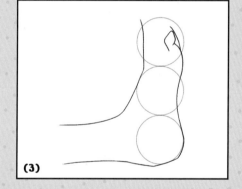

(3)

Start from the ankle and outline the bottom of the foot.

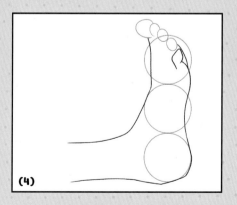

(4)

Add the curve of the upper edge of the foot.

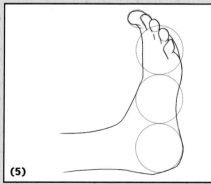

(5)

Draw the toes. Feel free to sketch little circles to help map out their positions.

TIP FOR DRAWING THE TOES!

Start with the farthest toe, then draw little C shapes for each toe getting closer to your view.

Use the guidelines to practice drawing the three foot variations. Use the space below to recreate feet without the guidelines, or draw your own foot poses.

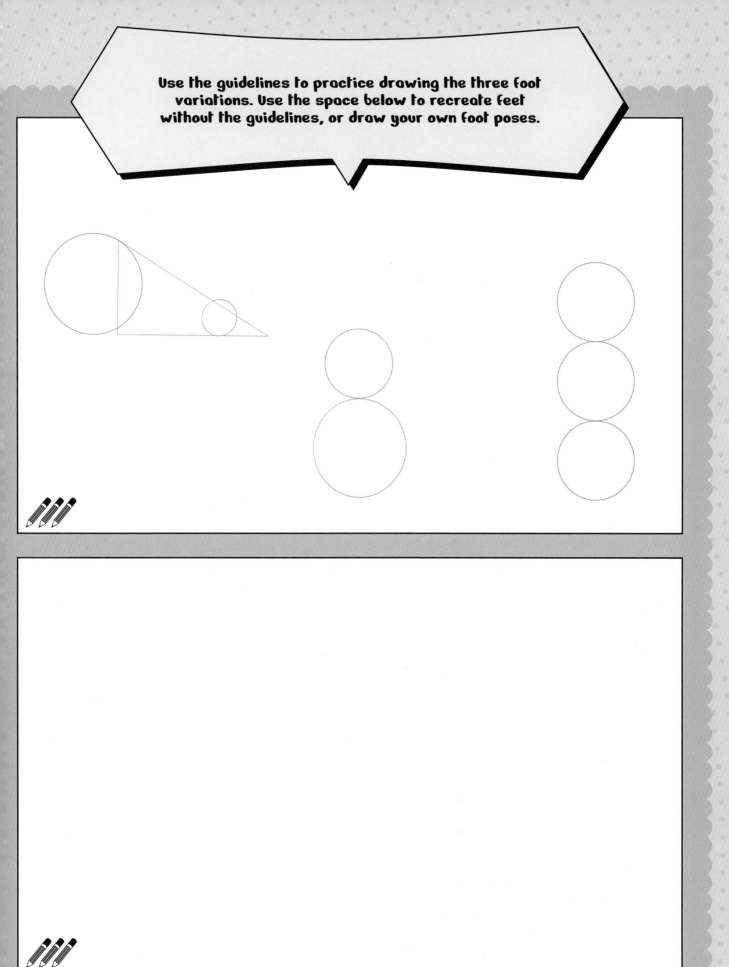

Foot Positions

In this tutorial, we are going to draw a foot on tiptoes from a side view. The reference box below also shows some alternative angles.

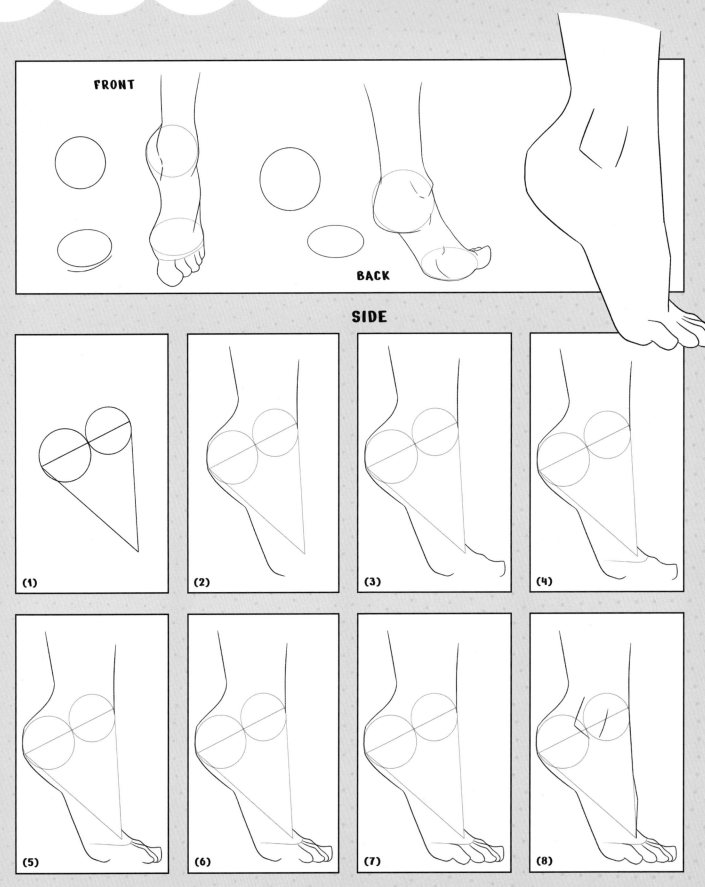

FRONT

BACK

SIDE

(1)

(2)

(3)

(4)

(5)

(6)

(7)

(8)

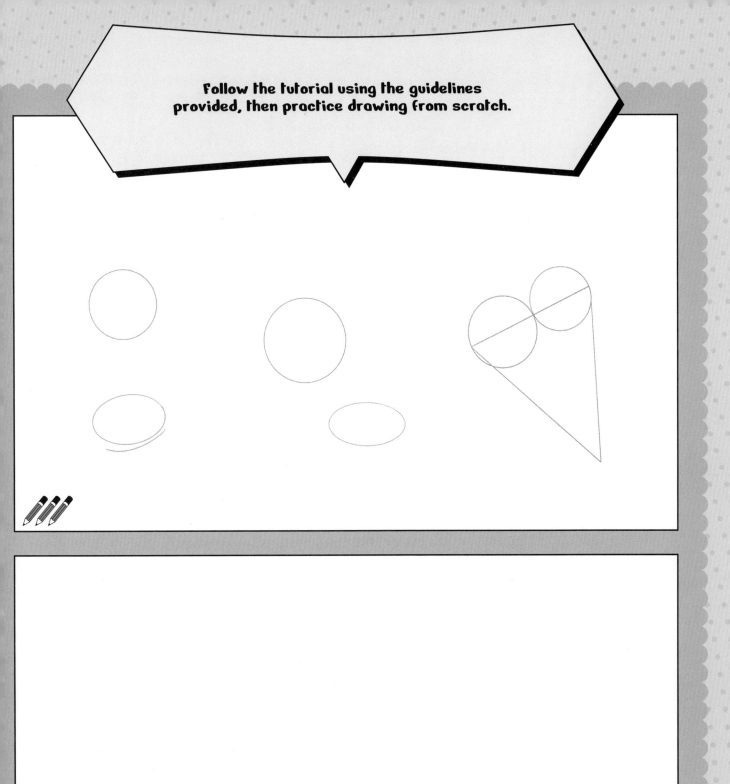

Follow the tutorial using the guidelines provided, then practice drawing from scratch.

Drawing the Female Torso

This section focuses on how to approach drawing a torso. This is the core of a position and can dictate a lot about the weight distribution of the body and the flow of an illustration.

FEMALE TORSO REFERENCES

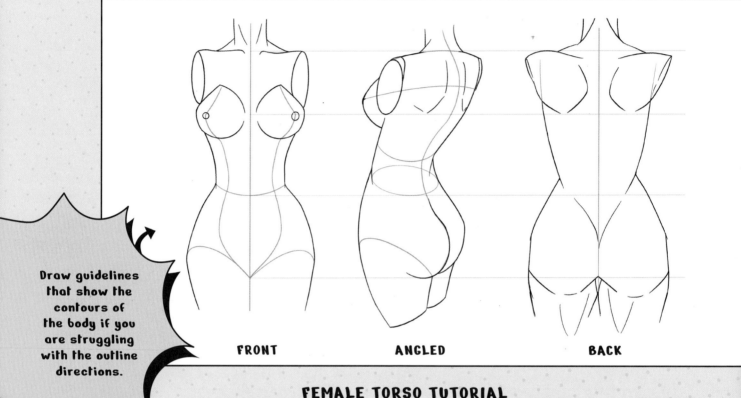

FRONT ANGLED BACK

Draw guidelines that show the contours of the body if you are struggling with the outline directions.

FEMALE TORSO TUTORIAL

To break down the torso step by step, let's look at an angled torso. The chapter opener shows this angle on a completed character for reference.

(1)

Draw the spine curve.

(2)

Extend the curve down around the gluteal muscles that form the buttocks.

(3)

Draw a curve going across the top spine curve. Then a similar one where the shoulders lie.

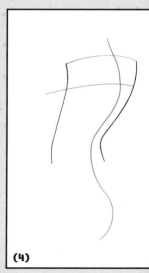

(4)

Sketch the sides of the back

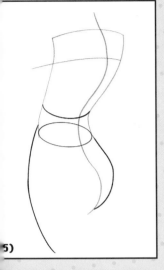 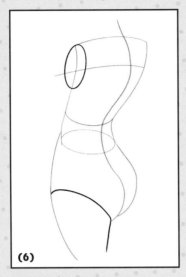 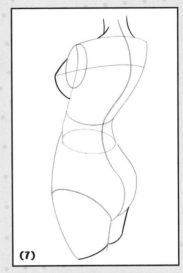 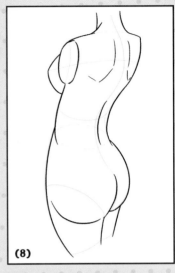

5)

...tend the back lines to create ...e leg and buttock curves.

(6)

Add an oval where the arm would go and begin to define the top of the leg.

(7)

Add in the other leg, breast, and neck. Breasts are flat on the top and curved underneath because of the way gravity pulls them down.

(8)

Go over the final piece in ink, adding little details like back dimples and bone outlines.

Practice drawing the three torso variations in the space below.

Drawing the Male Torso

Focus on getting the overall shape first, then add details and curves. Use straight lines and quick movements, then build over those sketch lines.

MALE TORSO REFERENCES

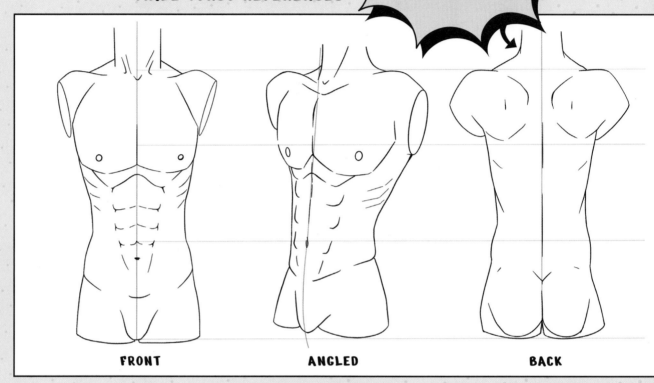

FRONT ANGLED BACK

MALE TORSO TUTORIAL

To break down how to draw the torso step by step, let's look at the angled torso.

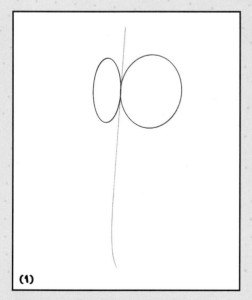

(1)

Draw the main body line. Add two ovals where the pecs are. The furthest one is more "squished" than the other.

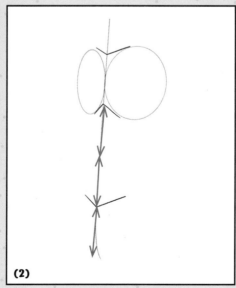

(2)

Add cornering points at the indicated spots along the body line.

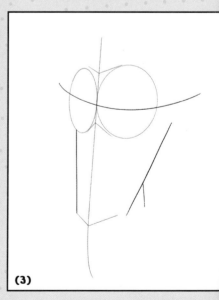

(3)

Draw a curve across the pecs to indicate the contour of the body. Then draw two converging lines toward the bottom V.

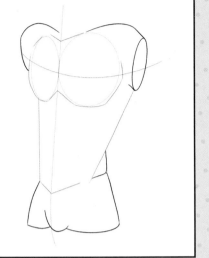

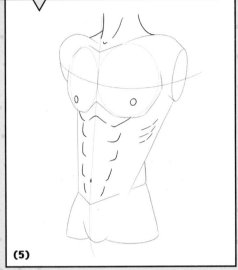

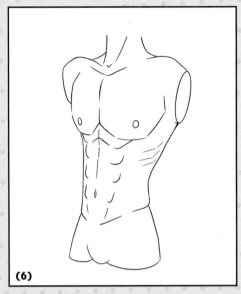

(5)

(6)

...e the guidelines to add the shoulders
...d top of the legs.

Draw in details of the neck, nipples, and
any visible muscles.

Go over the final piece in ink and erase any
pencil lines.

**Practice drawing the three torso
variations in the space below.**

Arm Positions

Here we'll learn how to draw arms, as well as a method to place them in any position you will need.

BREAKDOWN OF THE ARM: VERTICAL VARIATIONS

Notice that in the palm reference image, the hand guideline starts above the wrist joint. This is because when the arm and hand are outstretched, it can tilt back a little, raising the diamond guide position.

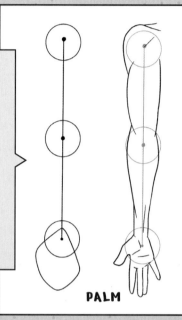

PALM

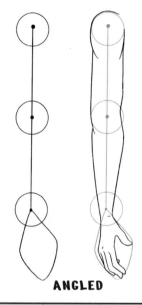

ANGLED

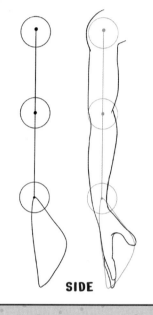

SIDE

ARM TUTORIAL

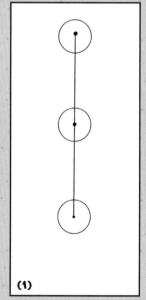

(1)

Draw a line. At the top, draw a dot where the shoulder is. Next, a dot where the wrist is. Finally, a dot halfway between the two, to mark the elbow joint.

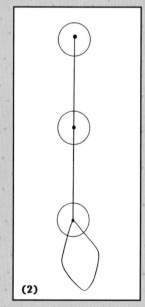

(2)

Use each joint pinpoint as the centers of three small circles.

(3)

Map out the hand position with a diamond (or triangle, depending on the angle of your hand).

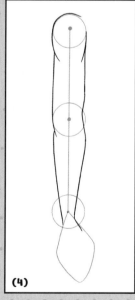

(4)

Join up the circles by mimicking the lines in the reference image you are using.

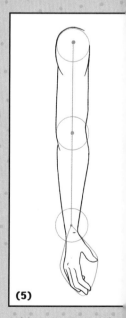

(5)

Add as many muscle details as you need for the character. Use the image above to know where the muscles lie

Practice drawing the three arm variations in the space below using the pre-drawn guidelines. Then, draw the arms from scratch.

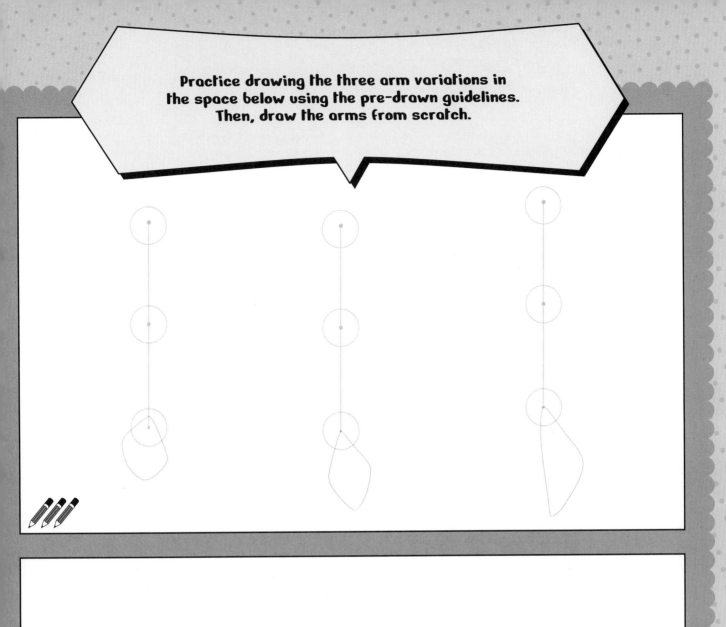

Arm Positions

Using the same method as outlined on the previous page, we are now going to draw arms at other angles.

FORWARD

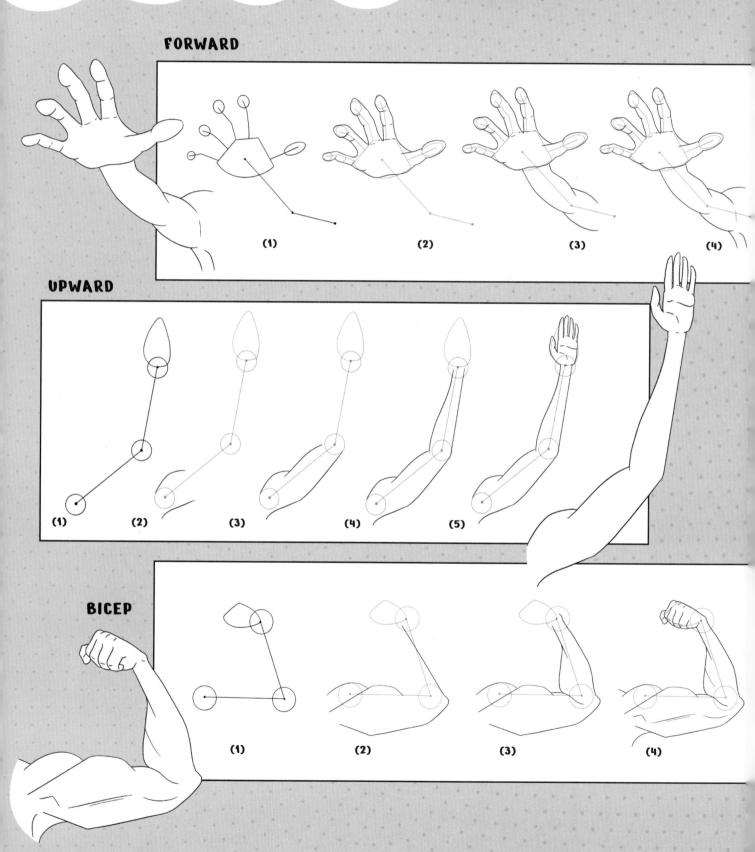

(1)　　　(2)　　　(3)　　　(4)

UPWARD

(1)　　(2)　　(3)　　(4)　　(5)

BICEP

(1)　　　(2)　　　(3)　　　(4)

Practice drawing the three hand variations in the space below, first with the guidelines on the left, and then freehand on the right.

Leg Positions

Let's learn how to approach drawing legs from three different views.

Where you have areas of muscle, add extra guiding shapes. Then add your final outlines.

VERTICAL LEG: FRONT, SIDE, AND BACK VIEWS

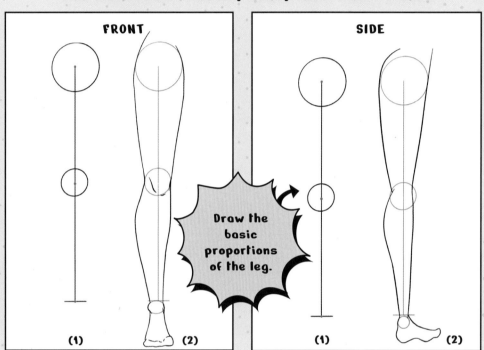
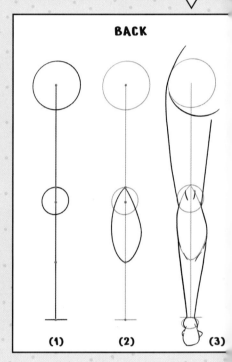

FRONT

(1) (2)

Draw the basic proportions of the leg.

SIDE

(1) (2)

BACK

(1) (2) (3)

LEG TUTORIAL

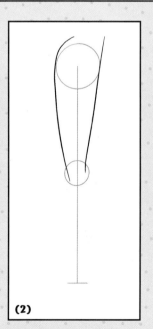
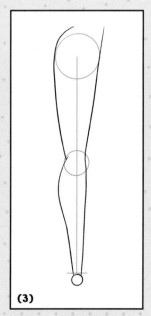
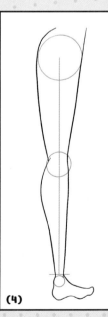

(1)

(2)

(3)

(4)

Draw a vertical line with dots to mark the hip, knee, and ankle. Draw circles around the hip and knee markers.

Draw the thigh outline, starting with a wider curve around the top circle and narrowing your lines toward the knee circle.

Draw the calf outline, narrowing your lines further as you reach the ankle baseline. Add a circle to show the ankle position.

Use your ankle circle as a placement guide when drawing the curves of the foot.

Practice drawing legs from the front, side, and back in the space below, using the given guidelines. Then, use the second box to practice without the guidelines

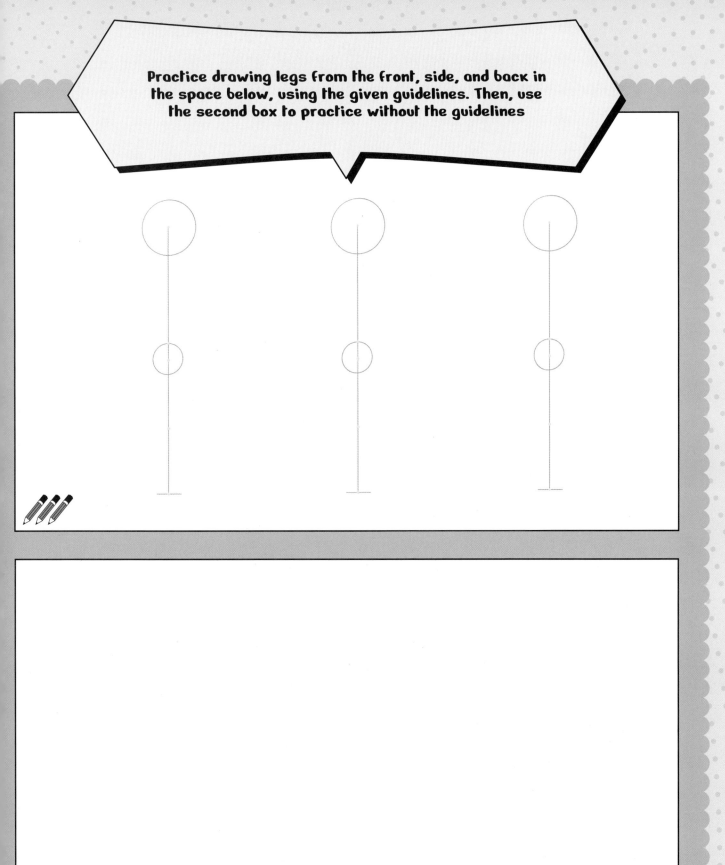

Leg Positions

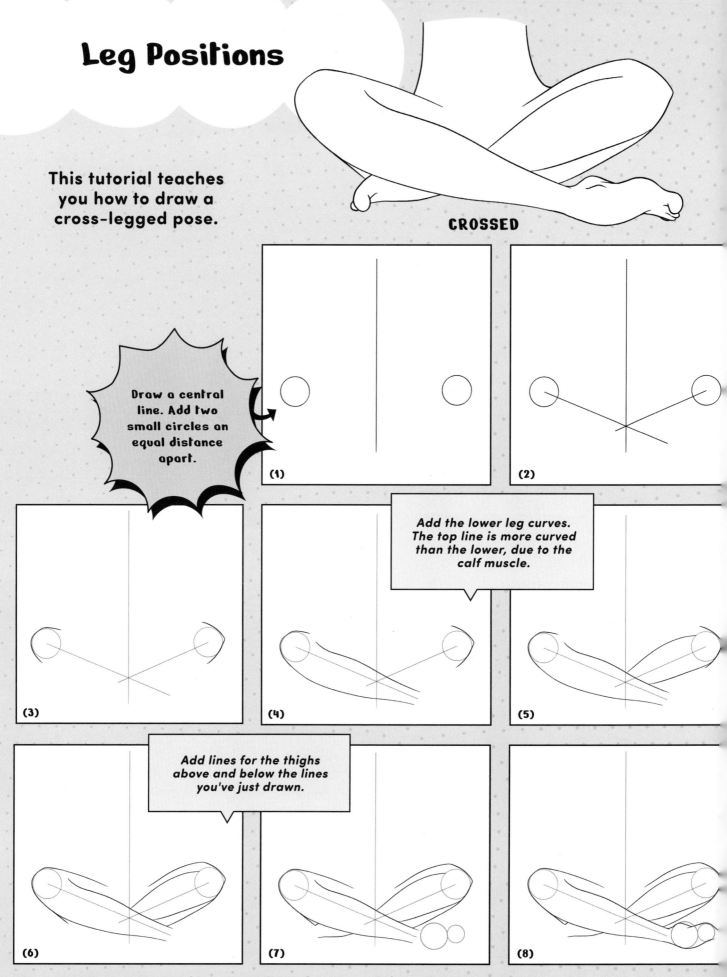

This tutorial teaches you how to draw a cross-legged pose.

CROSSED

Draw a central line. Add two small circles an equal distance apart.

(1)

(2)

(3)

Add the lower leg curves. The top line is more curved than the lower, due to the calf muscle.

(4)

(5)

Add lines for the thighs above and below the lines you've just drawn.

(6)

(7)

(8)

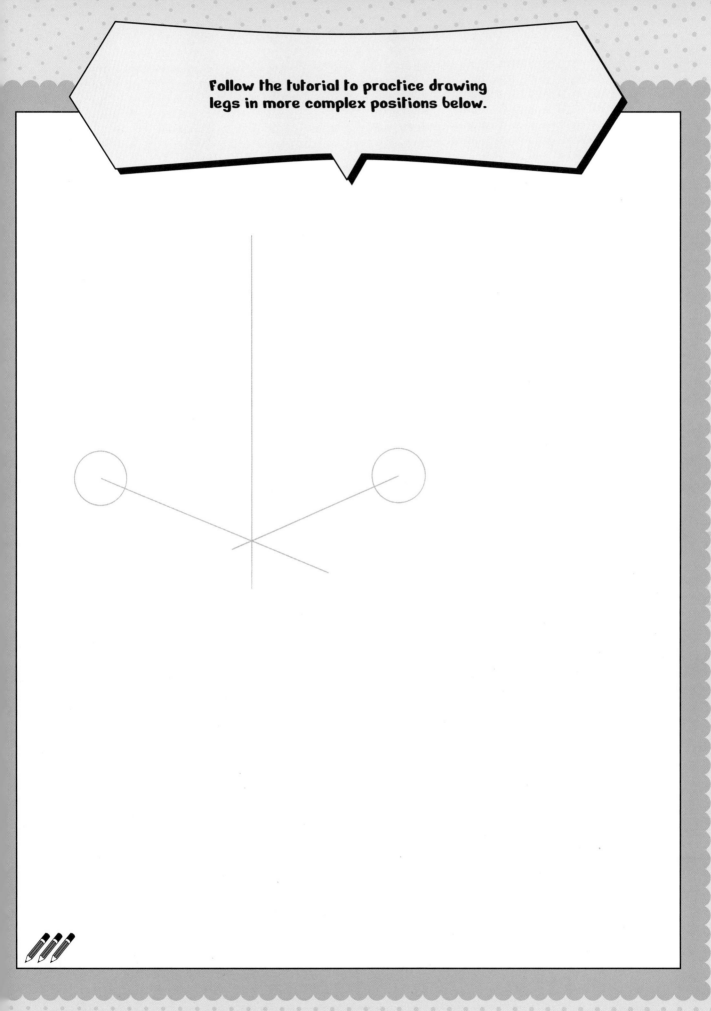

Leg Positions

Follow this tutorial to draw an extended and bent leg.

EXTENDED AND BENT LEG

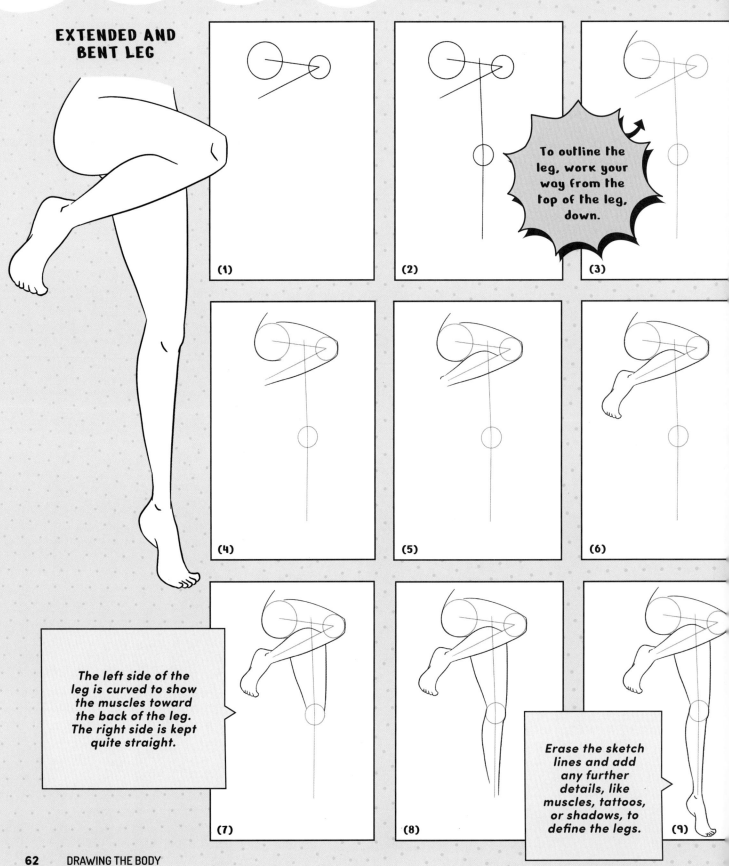

(1)

(2)

(3) To outline the leg, work your way from the top of the leg, down.

(4)

(5)

(6)

(7) The left side of the leg is curved to show the muscles toward the back of the leg. The right side is kept quite straight.

(8)

(9) Erase the sketch lines and add any further details, like muscles, tattoos, or shadows, to define the legs.

Follow the tutorial to practice drawing legs in more complex positions below.

Drawing Heads: Front View

Let's learn how to draw a head from a front view.

FRONT VIEW

(1)

Map the basic shapes.

(2)

Begin the curve of the chin.

(3)

Outline the face.

(4)

(5)

Start adding the facial features.

(6)

(7)

(8)

(9)

Add final details and shading.

(10)

Follow the tutorial to practice drawing the example character head from the front. Next, draw your own characters, adjusting the features such as eyes and hair.

Drawing Heads: Side View

You'll likely draw characters from many different angles, so let's learn how how to draw a face seen from the side.

SIDE VIEW

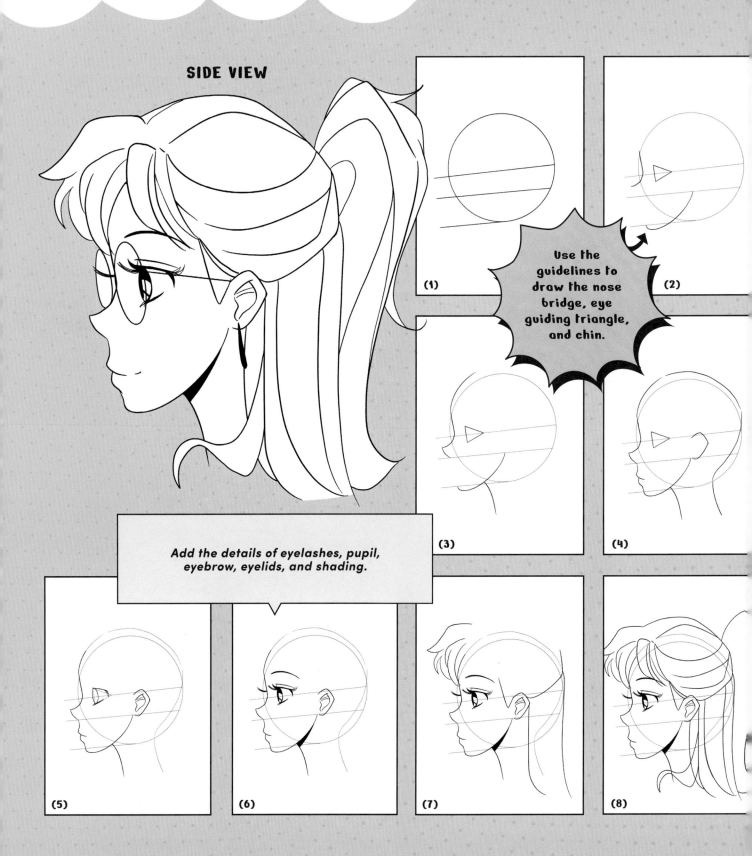

Use the guidelines to draw the nose bridge, eye guiding triangle, and chin.

Add the details of eyelashes, pupil, eyebrow, eyelids, and shading.

(1)

(2)

(3)

(4)

(5)

(6)

(7)

(8)

Follow the tutorial to practice drawing the example character at a side angle below. Next, draw your own character at this angle.

Drawing Heads: Three-quarter View

In this tutorial we'll learn how to draw a head from another popular angle: the three-quarter view.

THREE-QUARTER VIEW

Outline the head.

Add in the details of the face such as mouth, eyebrows, eyelids, and pupils.

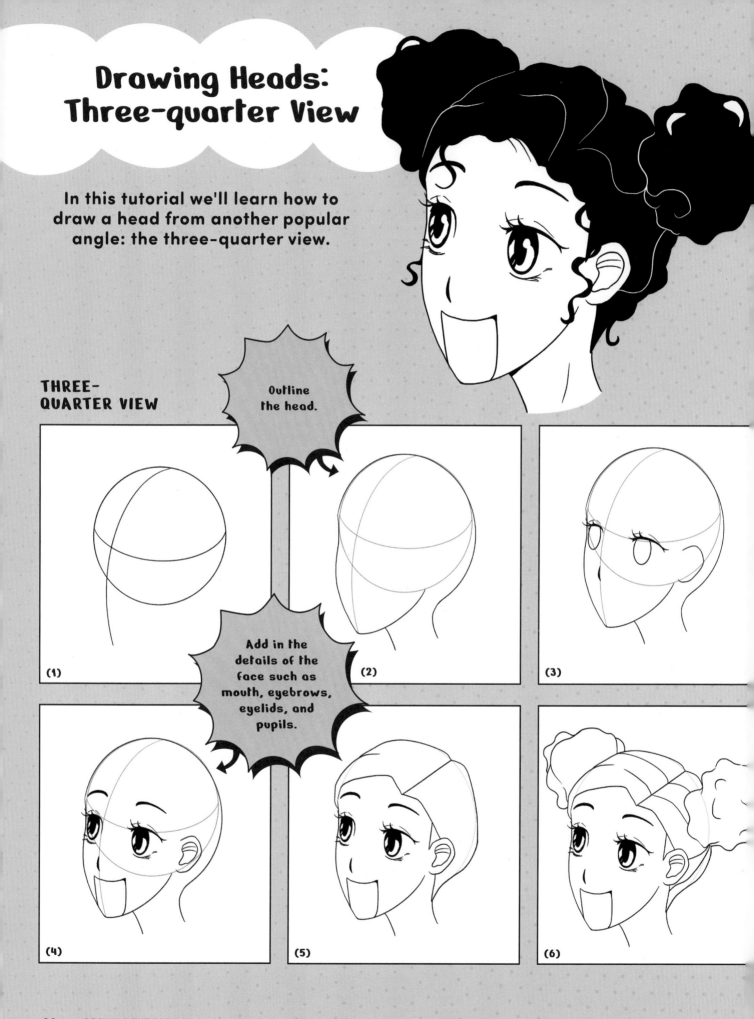

(1)

(2)

(3)

(4)

(5)

(6)

Follow the tutorial to practice drawing the example character head from a three-quarter view. Next, draw your own characters from all three angles using the first three steps of each tutorial. Then, adjust the features such as eyes and hair.

Adding Clothing

Here's how to draw some example clothes. First, let's practice some skirts!

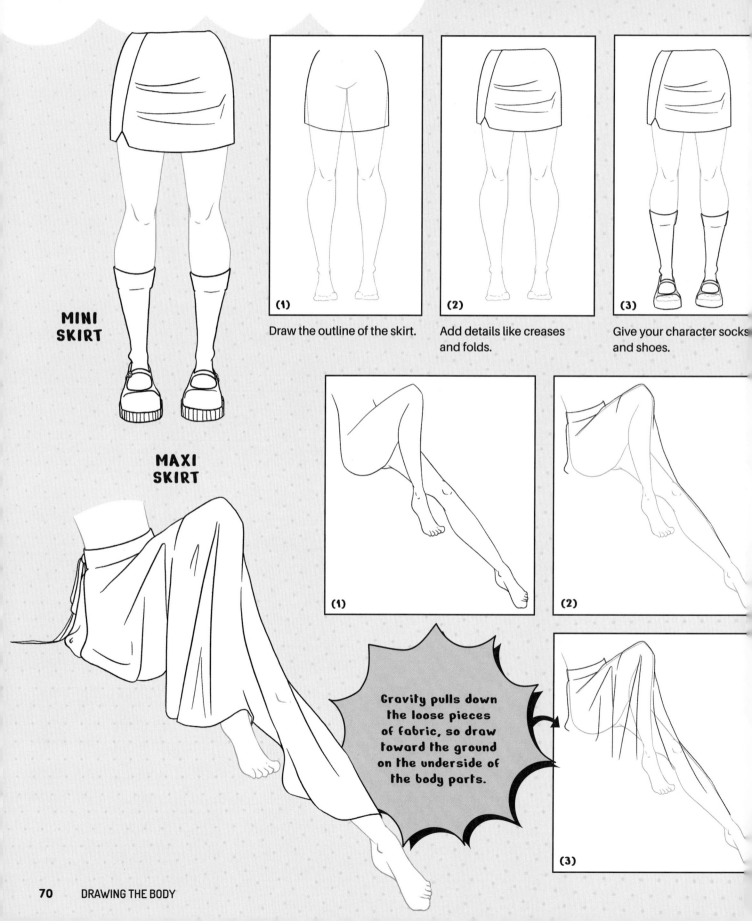

MINI SKIRT

(1) Draw the outline of the skirt.

(2) Add details like creases and folds.

(3) Give your character socks and shoes.

MAXI SKIRT

(1)

(2)

Gravity pulls down the loose pieces of fabric, so draw toward the ground on the underside of the body parts.

(3)

Practice by adding skirts to the
body outlines drawn below.

Don't worry, we'll draw
some complete outfits in
the next few chapters.

In the meantime, you can
find this maxi skirt on one
of the characters in the
chapter opener.

Adding Clothing

Follow the steps below to add jeans to this cross-legged character.

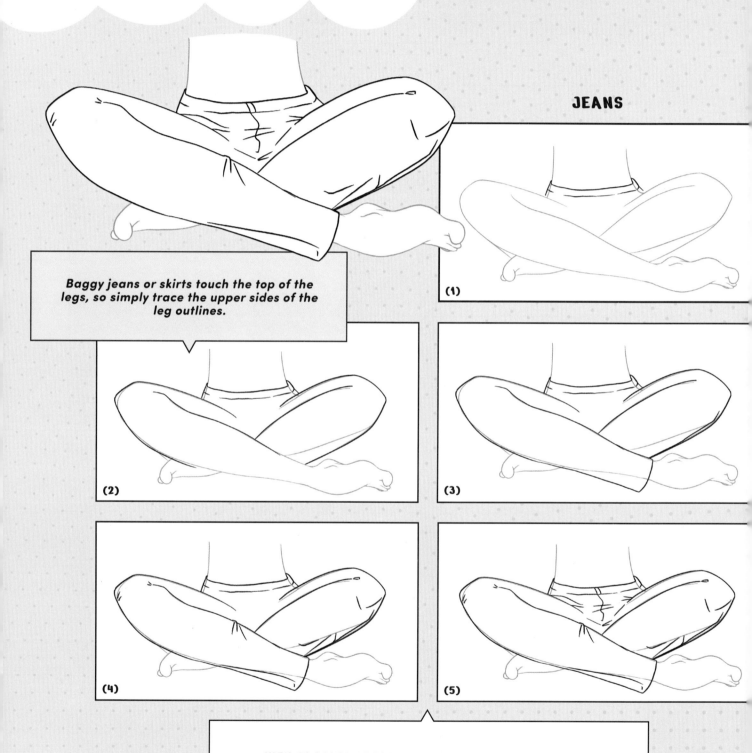

JEANS

Baggy jeans or skirts touch the top of the legs, so simply trace the upper sides of the leg outlines.

(1)

(2)

(3)

(4)

(5)

WHEN PLACING CREASES, ASK YOURSELF:
- Where is the material the tightest?
- Between which points is the material being pulled?
- How thick is the material? Thicker material means fewer and wider crease lines.

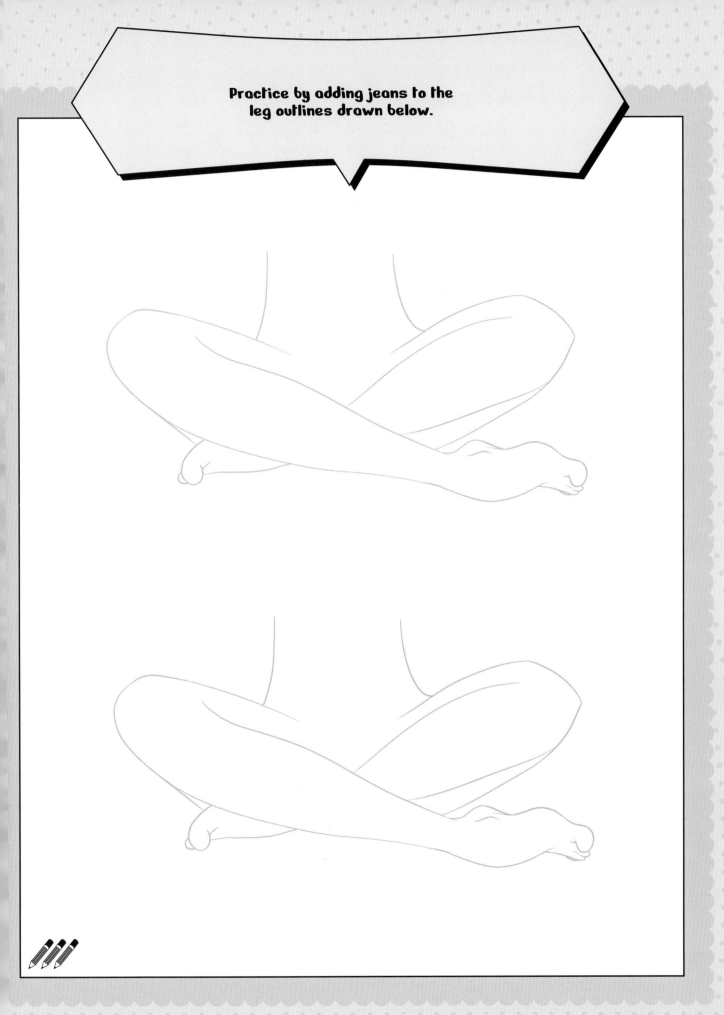

Practice by adding jeans to the
leg outlines drawn below.

Adding Clothing

Here are some clothing examples for the upper part of the body.

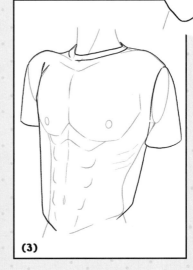

TUCKED-IN T-SHIRT

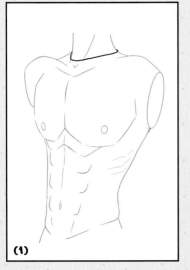

(1)

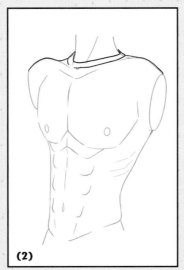

(2)

(3)

The T-shirt in this tutorial is loose fitting. The character has a broad upper body, so it lies flat over the pecs then hangs loosely down the torso. This results in crease lines below the pec area.

BELL-SLEEVED CARDIGAN

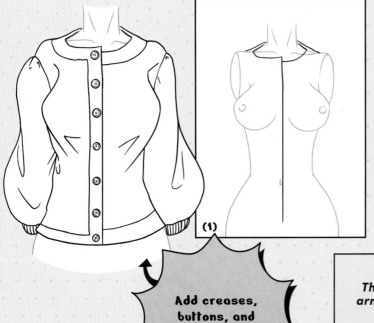

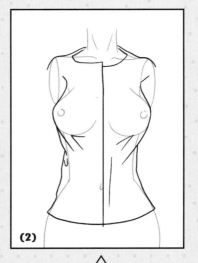

(1)

(2)

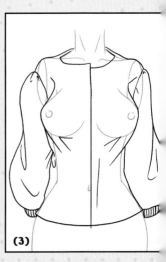

(3)

Add creases, buttons, and embellishments!

This cardigan is a loose fit along the arms but it follows the rough contours of the body.

Practice by giving the bodies below clothing,
either following the tutorials or drawing
them wearing your own favorite clothes.

CHAPTER 3

Static Poses

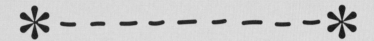

It's time to focus on complete character illustrations.

This chapter breaks down a series of static poses. This way, we can still focus on perfecting the body parts and proportions we've learned in the previous chapters before introducing movement to the piece.

The section starts with standing poses, moves to sitting ones, and finishes with reclined poses.

Static Poses: Standing

Follow this tutorial to capture a cool and playful character at a twisted angle, enjoying a lollipop.

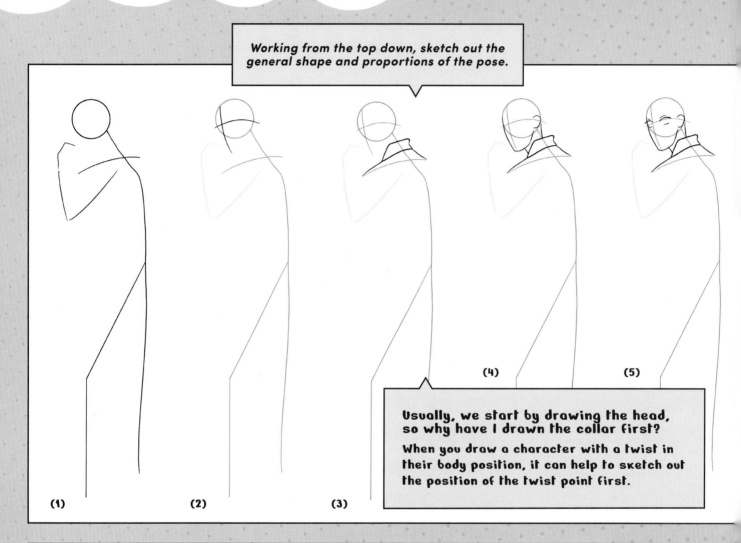

Working from the top down, sketch out the general shape and proportions of the pose.

Usually, we start by drawing the head, so why have I drawn the collar first?

When you draw a character with a twist in their body position, it can help to sketch out the position of the twist point first.

(1) (2) (3) (4) (5)

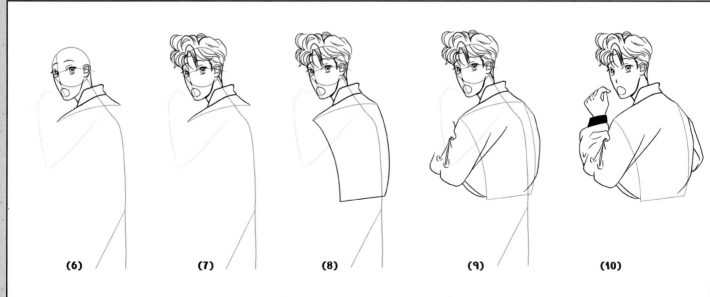

(6) (7) (8) (9) (10)

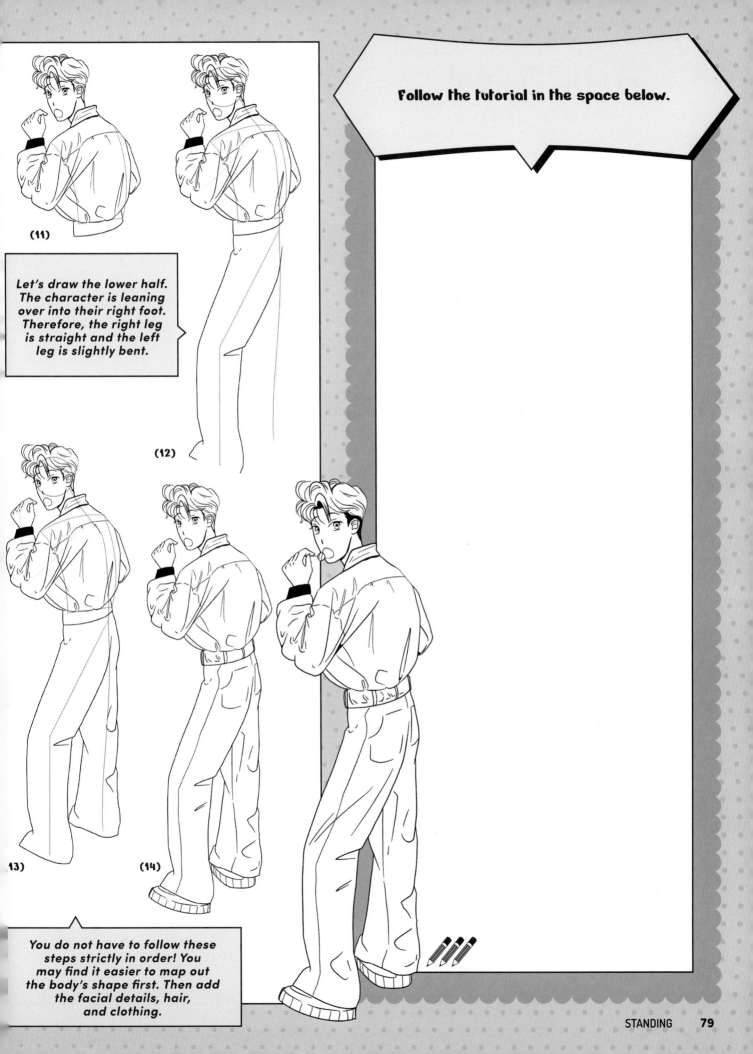

(11)

Let's draw the lower half. The character is leaning over into their right foot. Therefore, the right leg is straight and the left leg is slightly bent.

(12)

Follow the tutorial in the space below.

13)

(14)

You do not have to follow these steps strictly in order! You may find it easier to map out the body's shape first. Then add the facial details, hair, and clothing.

Static Poses: Standing

Follow this tutorial to draw a character standing in a cute pose, wearing a fun outfit with leg warmers.

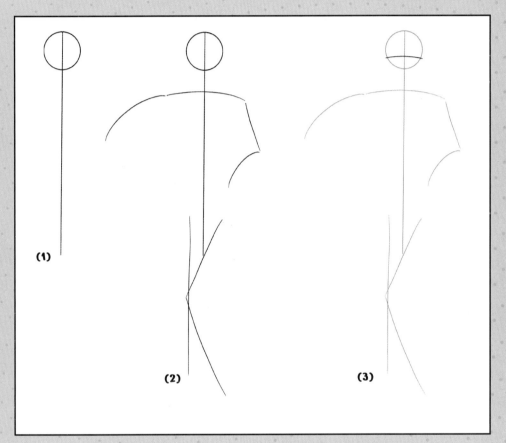

(1)

(2)

(3)

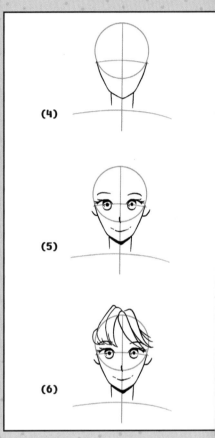

(4)

(5)

(6)

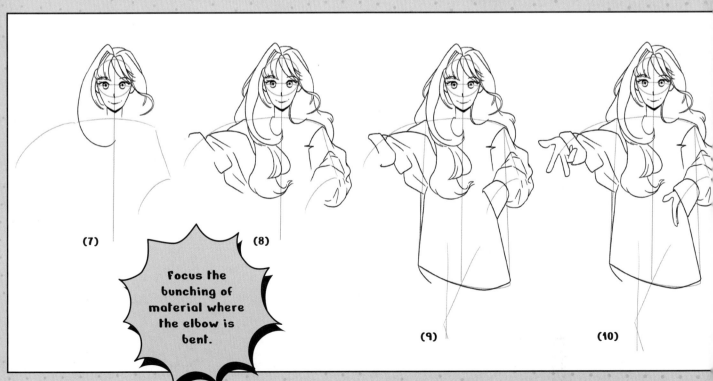

(7)

(8)

Focus the bunching of material where the elbow is bent.

(9)

(10)

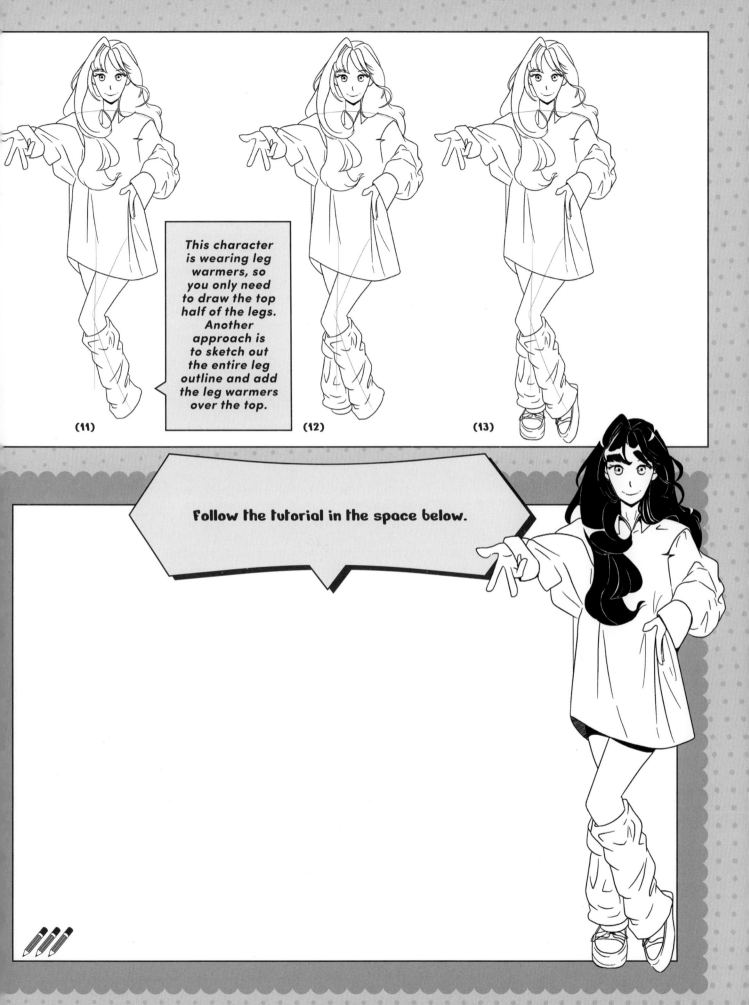

This character is wearing leg warmers, so you only need to draw the top half of the legs. Another approach is to sketch out the entire leg outline and add the leg warmers over the top.

(11)

(12)

(13)

Follow the tutorial in the space below.

Static Poses: Standing

Follow the tutorial to draw this curious character bending over to inspect something below him.

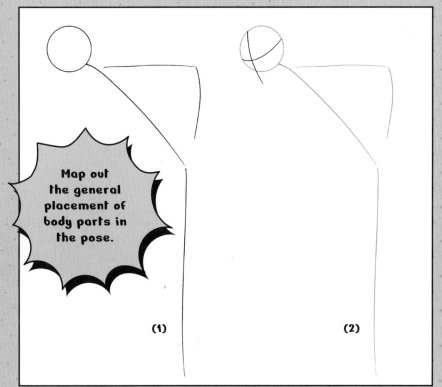

Map out the general placement of body parts in the pose.

(1)

(2)

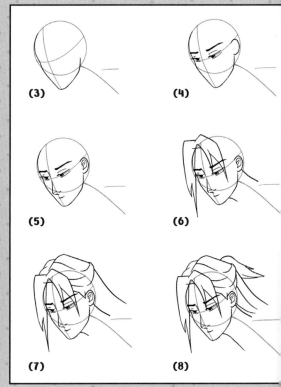

(3)

(4)

(5)

(6)

(7)

(8)

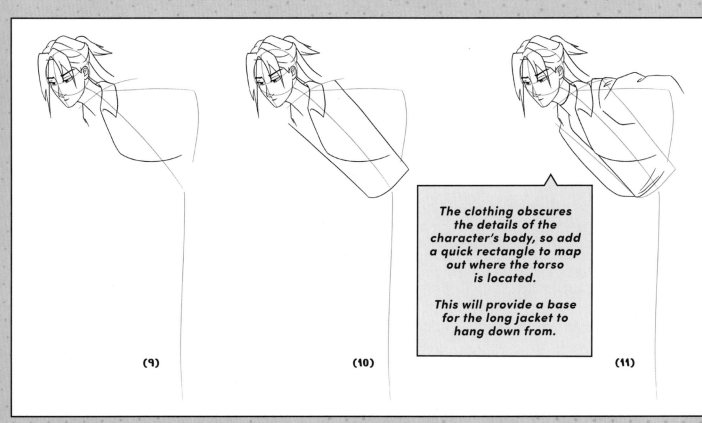

(9)

(10)

The clothing obscures the details of the character's body, so add a quick rectangle to map out where the torso is located.

This will provide a base for the long jacket to hang down from.

(11)

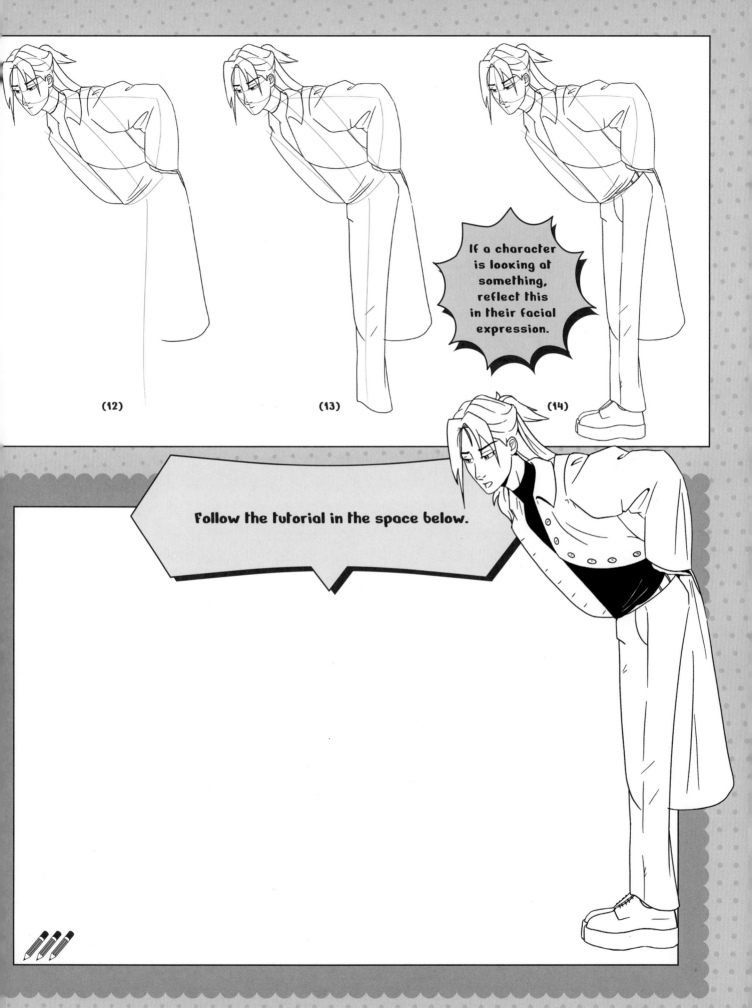

(12)

(13)

(14)

If a character is looking at something, reflect this in their facial expression.

Follow the tutorial in the space below.

Static Poses: Standing

This final character is a high-spirited woman with a style inspired by K-pop culture.

This character is leaning with most of her weight on her left leg, with a popped-out hip. As this is a key point of the body, it has been included in the initial guideline sketch.

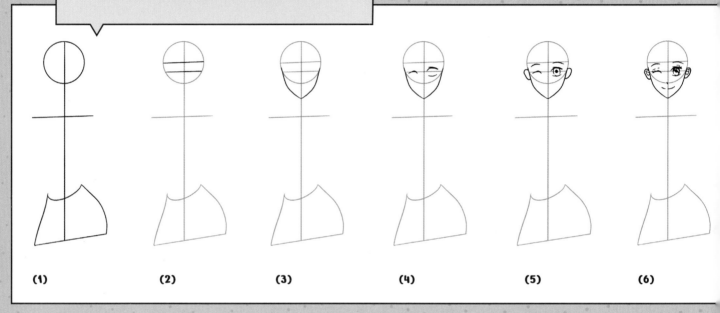

(1) (2) (3) (4) (5) (6)

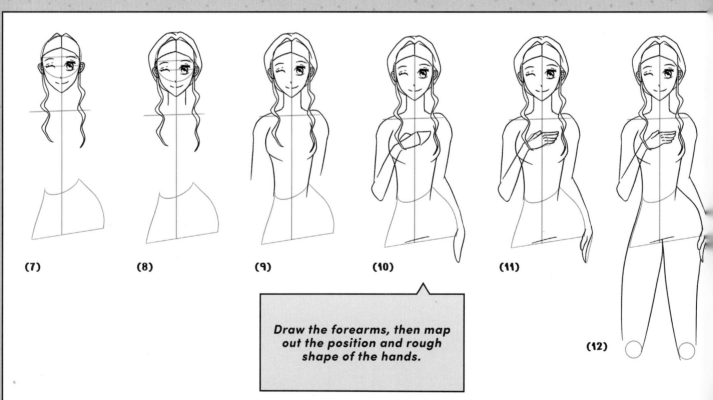

(7) (8) (9) (10) (11) (12)

Draw the forearms, then map out the position and rough shape of the hands.

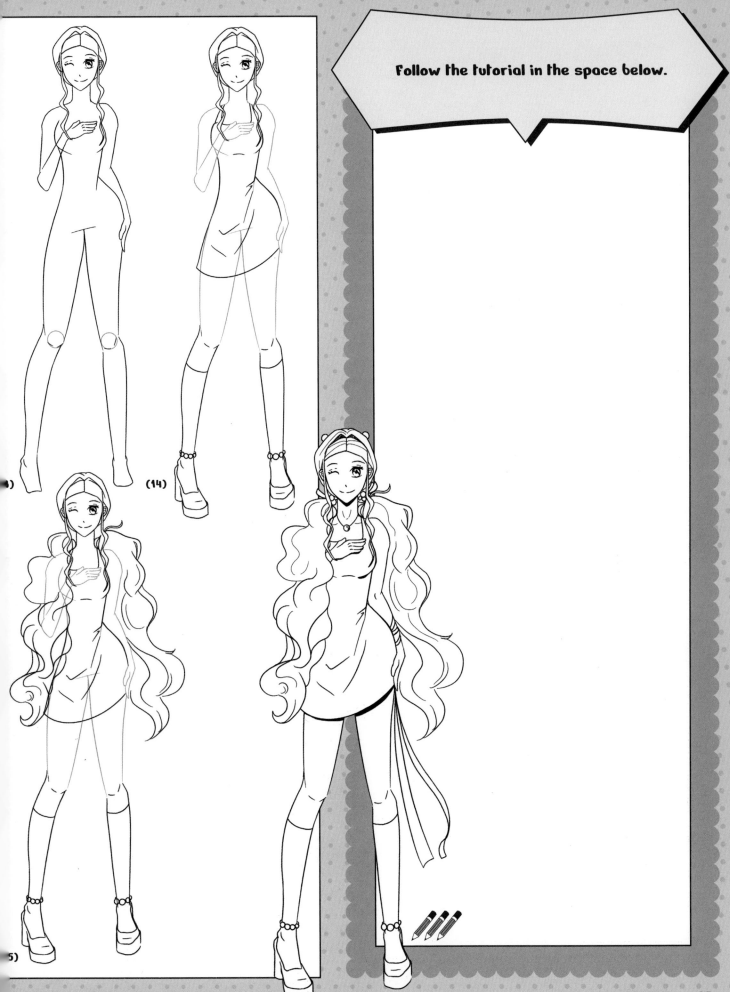

(14)

Static Poses: Sitting

Practice drawing this child sitting with her legs crossed. Pages 60-61 cover drawing crossed legs if you need to refer back to it.

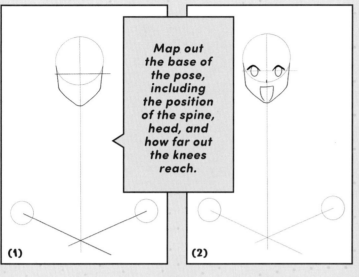

Map out the base of the pose, including the position of the spine, head, and how far out the knees reach.

(1)

(2)

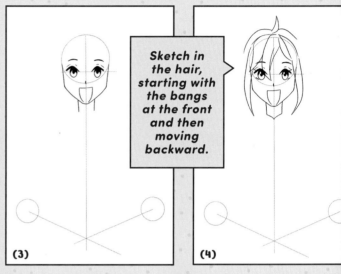

Sketch in the hair, starting with the bangs at the front and then moving backward.

(3)

(4)

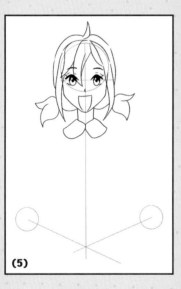

(5)

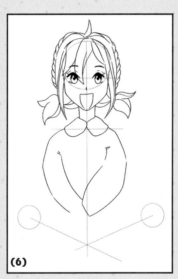

(6)

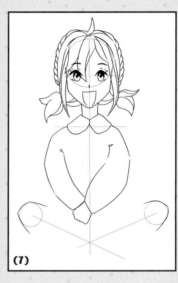

(7)

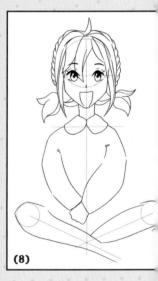

(8)

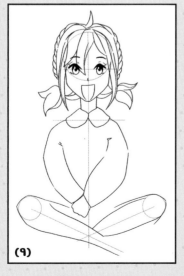

(9)

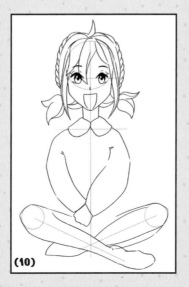

(10)

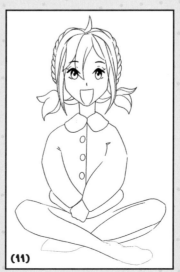

(11)

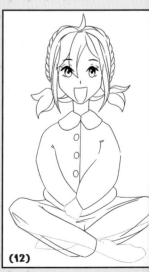

(12)

Follow the tutorial in the space below.

Static Poses: Sitting

Follow this tutorial to draw a brooding character in a slouched sitting position.

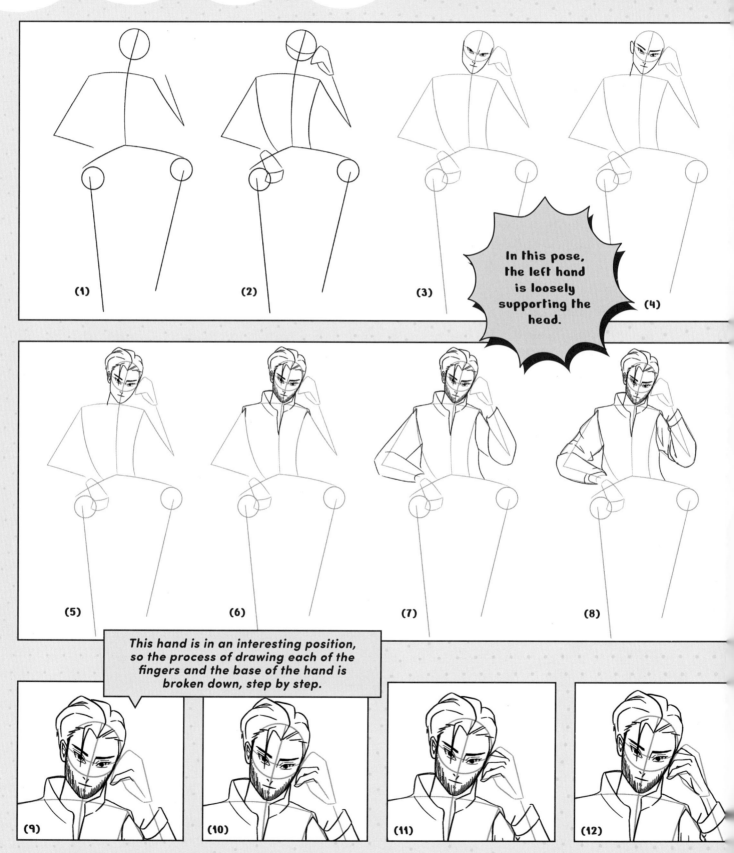

(1)

(2)

(3)

In this pose, the left hand is loosely supporting the head.

(4)

(5)

(6)

(7)

(8)

This hand is in an interesting position, so the process of drawing each of the fingers and the base of the hand is broken down, step by step.

(9)

(10)

(11)

(12)

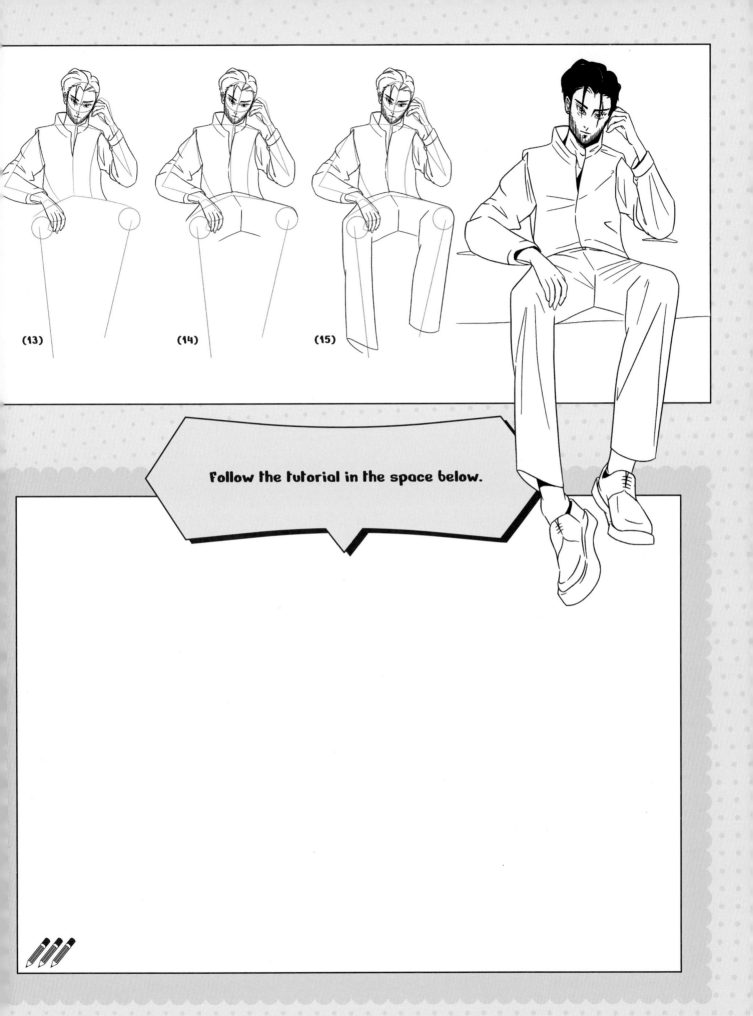

(13)

(14)

(15)

Follow the tutorial in the space below.

Static Poses: Sitting

Use this tutorial to draw a woman sitting with her arms extended behind her and her legs crossed.

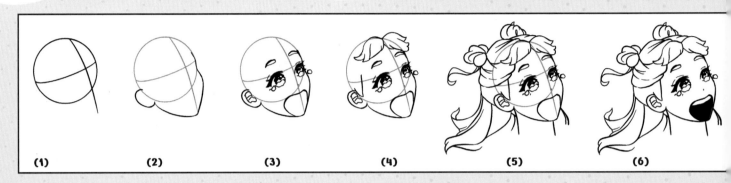

(1) (2) (3) (4) (5) (6)

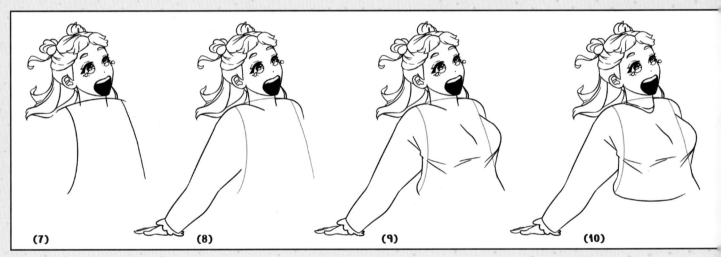

(7) (8) (9) (10)

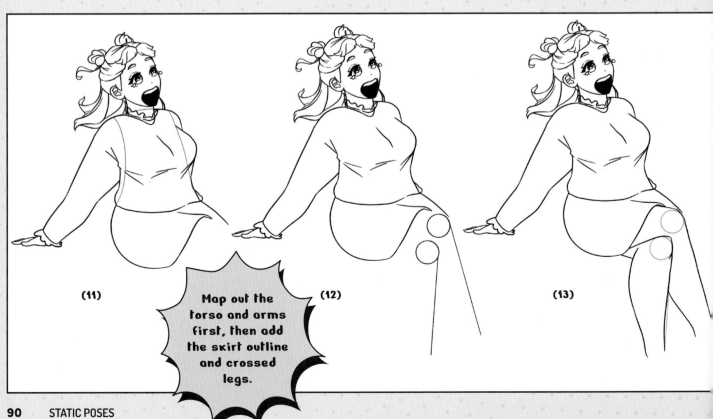

(11) (12) (13)

Map out the torso and arms first, then add the skirt outline and crossed legs.

Follow the tutorial in the space below.

Static Poses: Sitting

Follow this tutorial to draw a character leaning back with his arms and legs crossed.

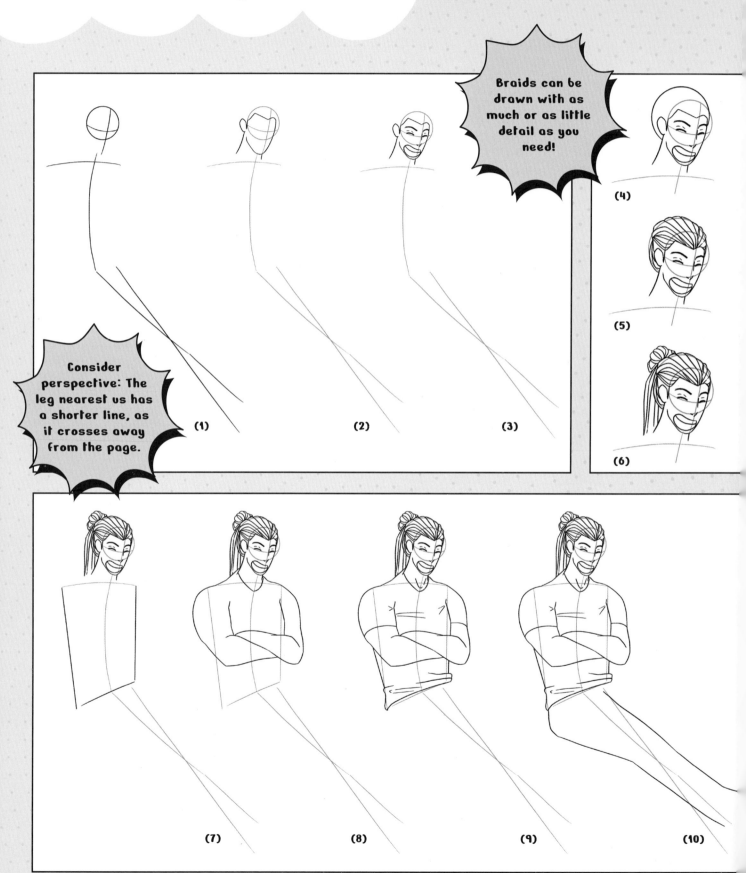

Braids can be drawn with as much or as little detail as you need!

Consider perspective: The leg nearest us has a shorter line, as it crosses away from the page.

(1)

(2)

(3)

(4)

(5)

(6)

(7)

(8)

(9)

(10)

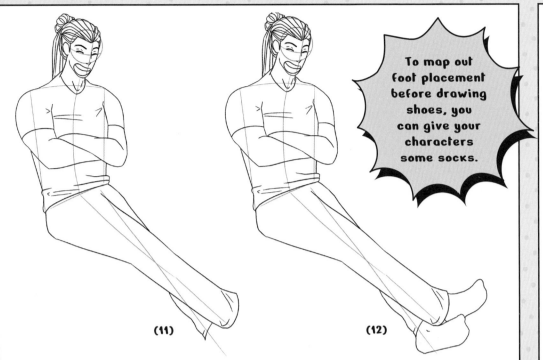

(11)

(12)

To map out foot placement before drawing shoes, you can give your characters some socks.

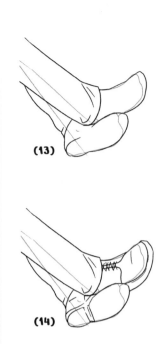

(13)

(14)

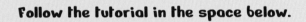

Follow the tutorial in the space below.

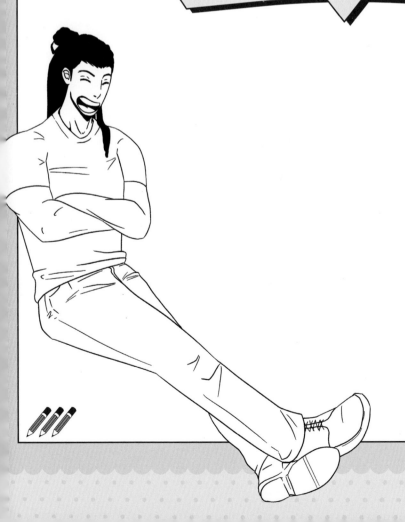

Static Poses: Reclined

This tutorial covers a character relaxing on his back, as seen from above.

Map out the positions and proportions of the head and the limbs.

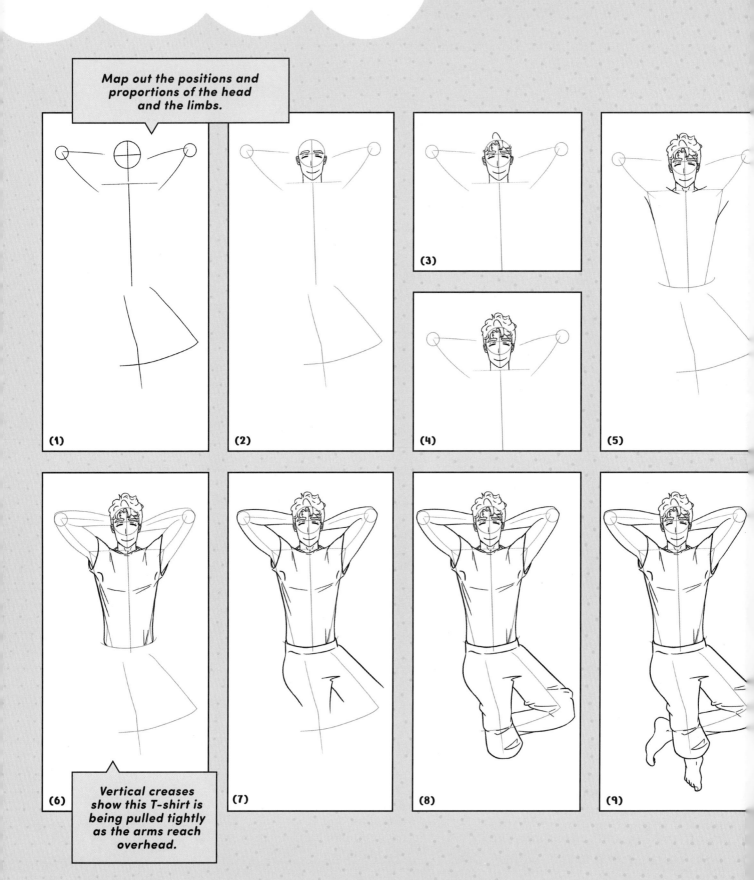

(1)

(2)

(3)

(4)

(5)

(6)

(7)

(8)

(9)

Vertical creases show this T-shirt is being pulled tightly as the arms reach overhead.

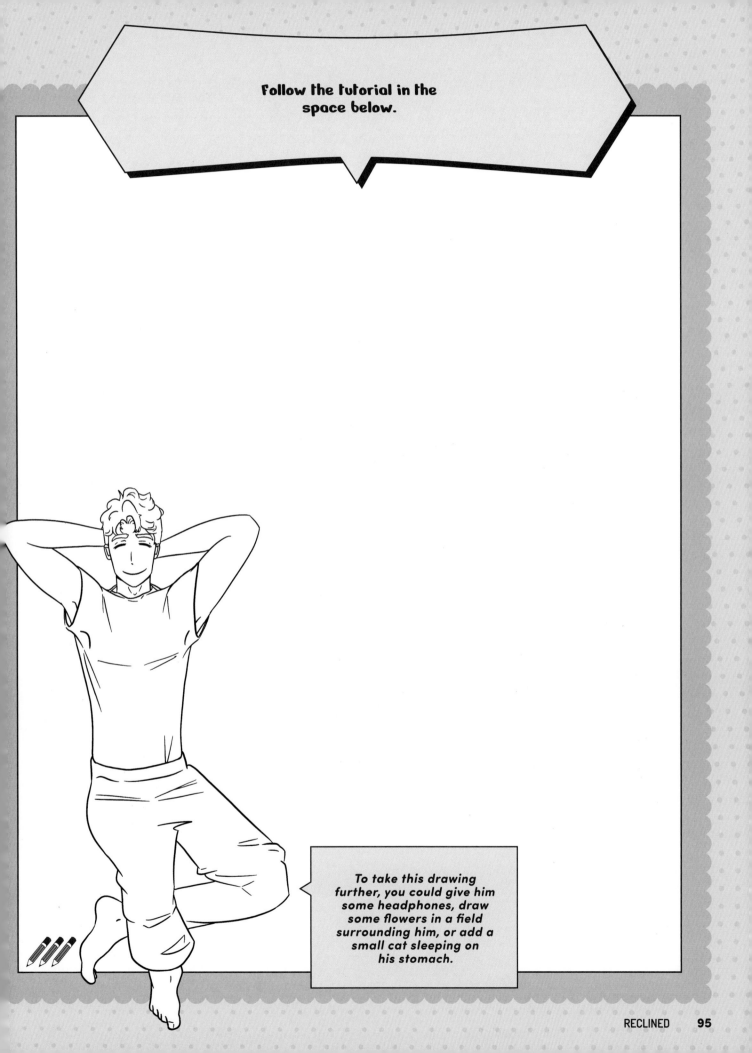

Follow the tutorial in the space below.

To take this drawing further, you could give him some headphones, draw some flowers in a field surrounding him, or add a small cat sleeping on his stomach.

Static Poses: Reclined

Follow this tutorial to create a character lying down on her stomach.

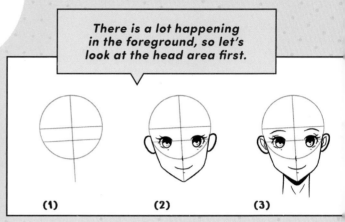

There is a lot happening in the foreground, so let's look at the head area first.

(1)　　(2)　　(3)

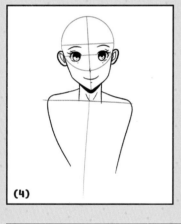

(4)

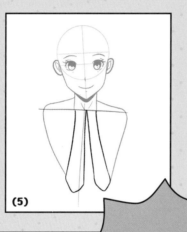

(5)

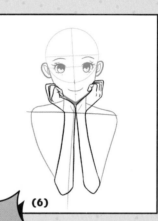

(6)

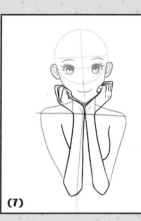

(7)

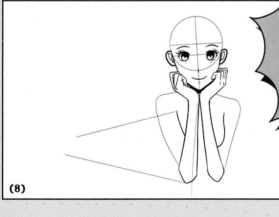

(8)

Follow the next steps carefully to add a body angled back into the page. Depth can be tricky.

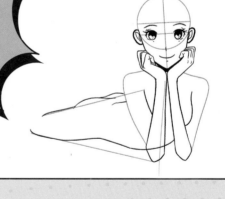

(9)

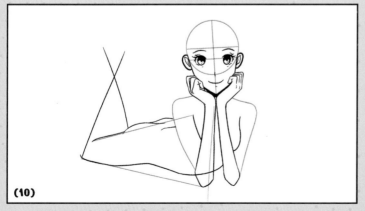

(10)

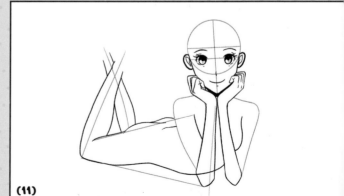

(11)

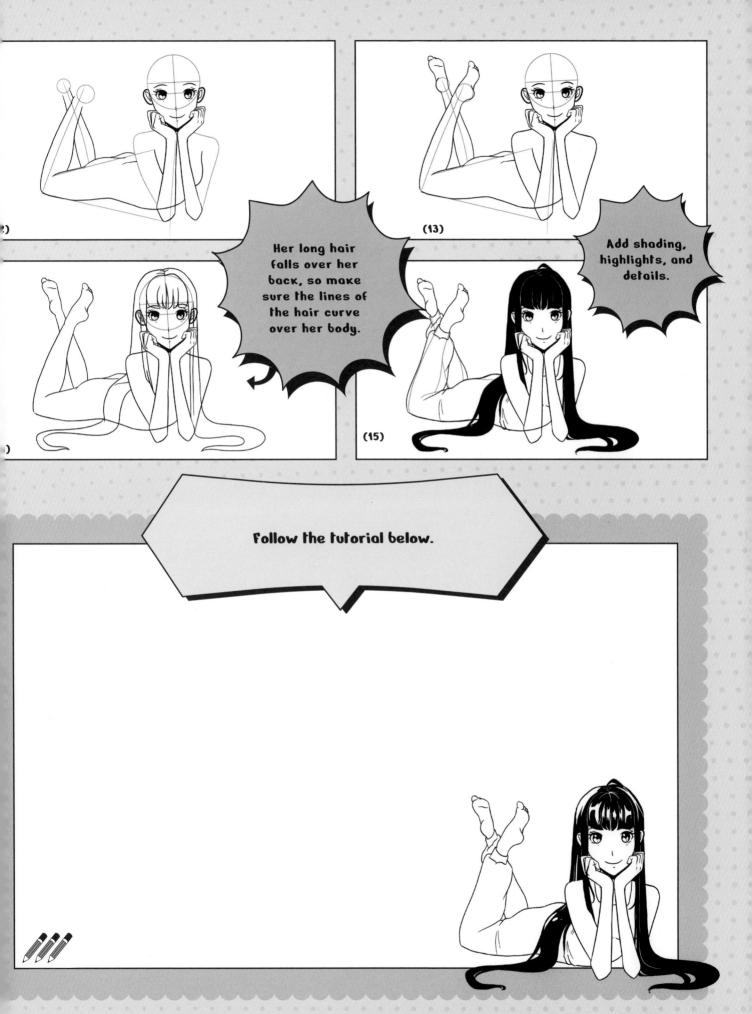

(13)

Her long hair falls over her back, so make sure the lines of the hair curve over her body.

Add shading, highlights, and details.

(15)

Follow the tutorial below.

Static Poses: Reclined

Follow the tutorial to draw this sleeping child lying on his side.

Add facial features, such as an open mouth, that convey he is having a peaceful night's sleep.

The left arm is not drawn here, since it lies under the pillow that will be drawn into the scene later.

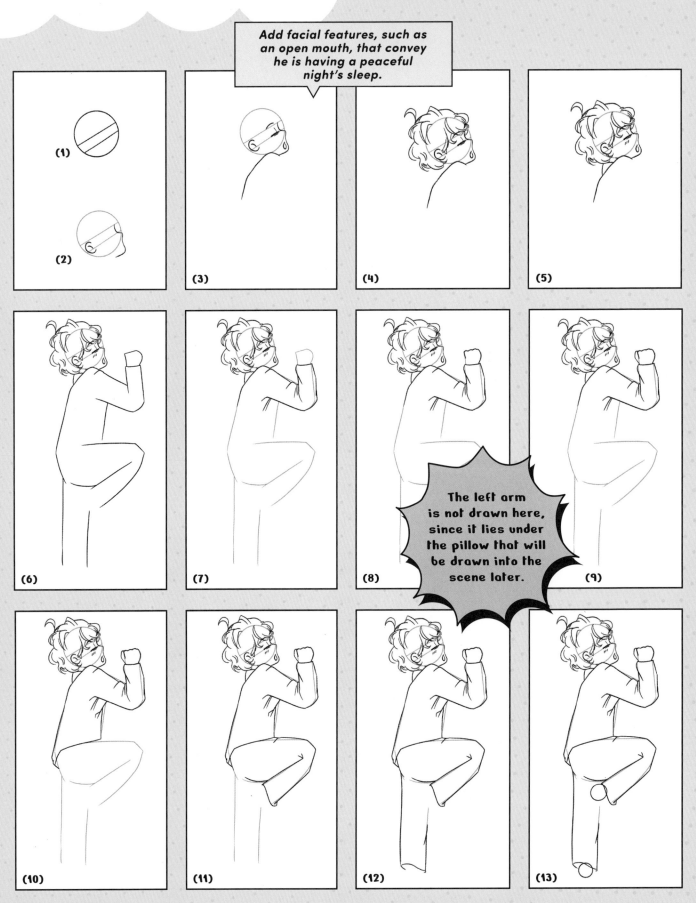

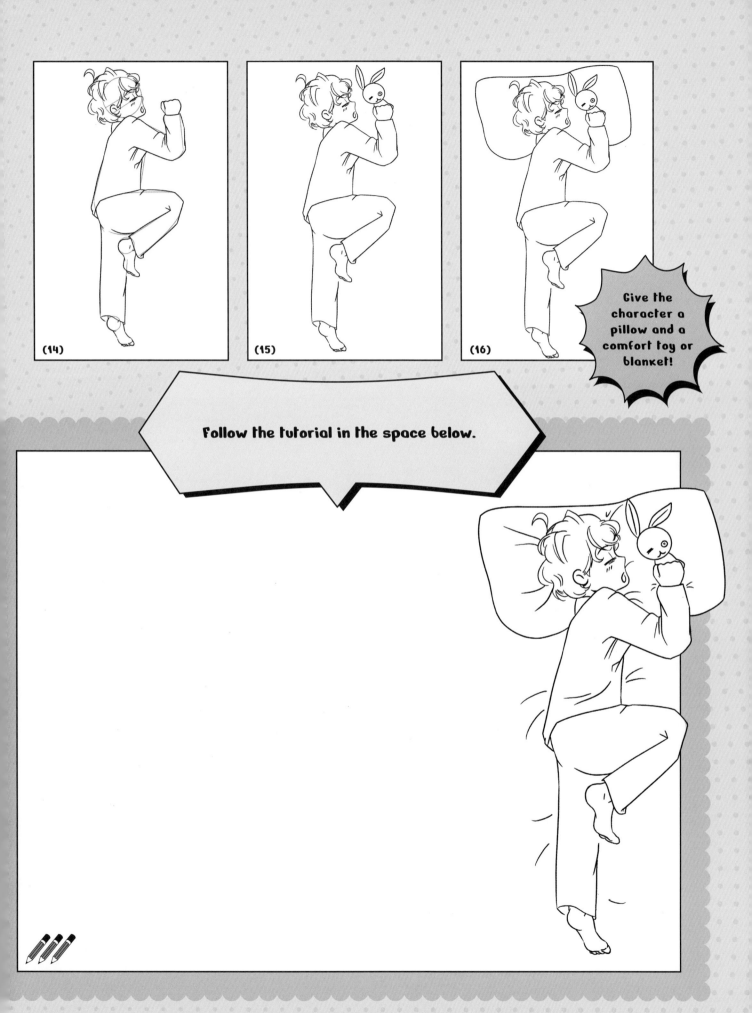

(14)

(15)

(16)

Give the character a pillow and a comfort toy or blanket!

Follow the tutorial in the space below.

Static Poses: Reclined

Follow the tutorial to draw a woman sleeping on her side.

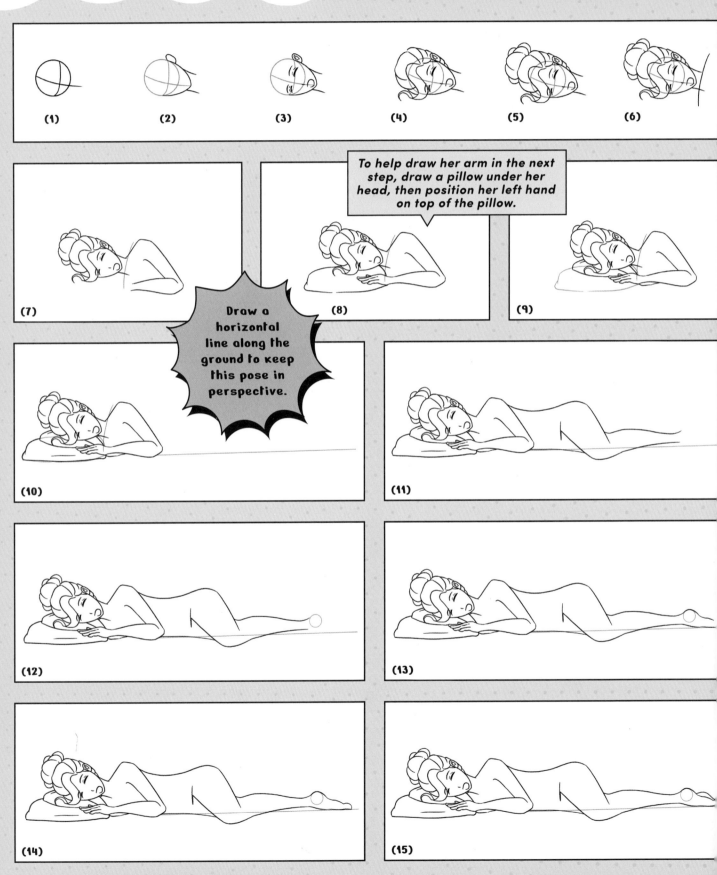

To help draw her arm in the next step, draw a pillow under her head, then position her left hand on top of the pillow.

Draw a horizontal line along the ground to keep this pose in perspective.

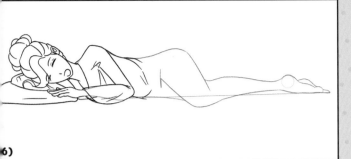

(16)

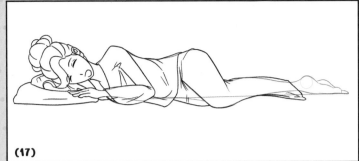

(17)

Practice drawing this sleeping character in the space below.

Add little snore bubbles above the sleeping character.

CHAPTER 4

Dynamic Poses

Now that you've mastered proportions and positioning, it's time to dive into some fun poses that show movement and energy!

This chapter brings your characters into motion with tutorials that teach you how to draw them in various dynamic poses, including walking, running, and jumping.

Dynamic Poses: Walking

This tutorial is for a cheerful character walking happily toward us.

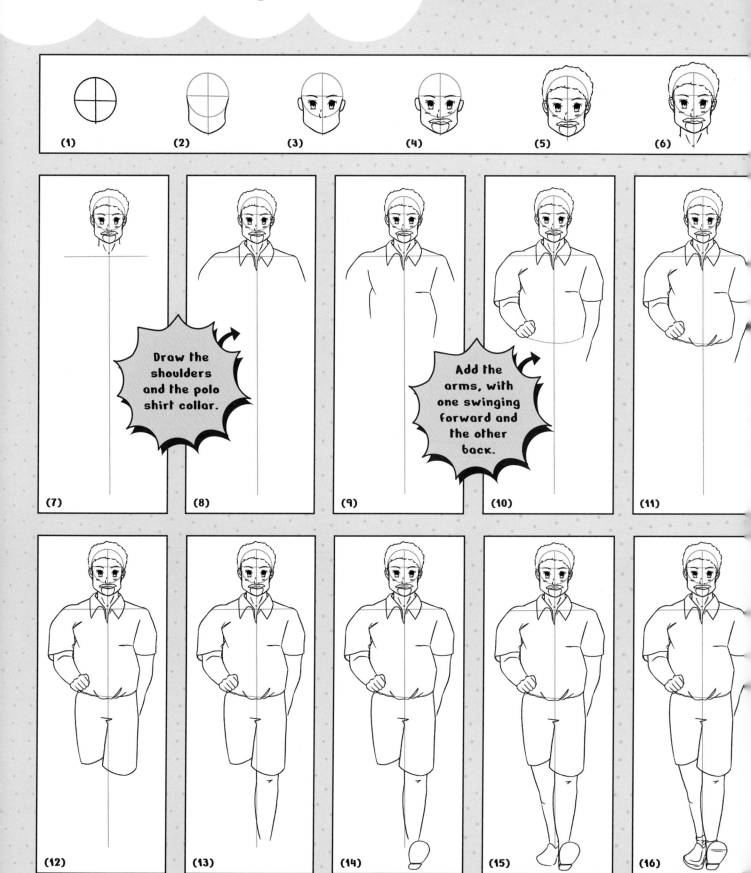

(1)

(2)

(3)

(4)

(5)

(6)

(7)

(8)

Draw the shoulders and the polo shirt collar.

(9)

(10)

Add the arms, with one swinging forward and the other back.

(11)

(12)

(13)

(14)

(15)

(16)

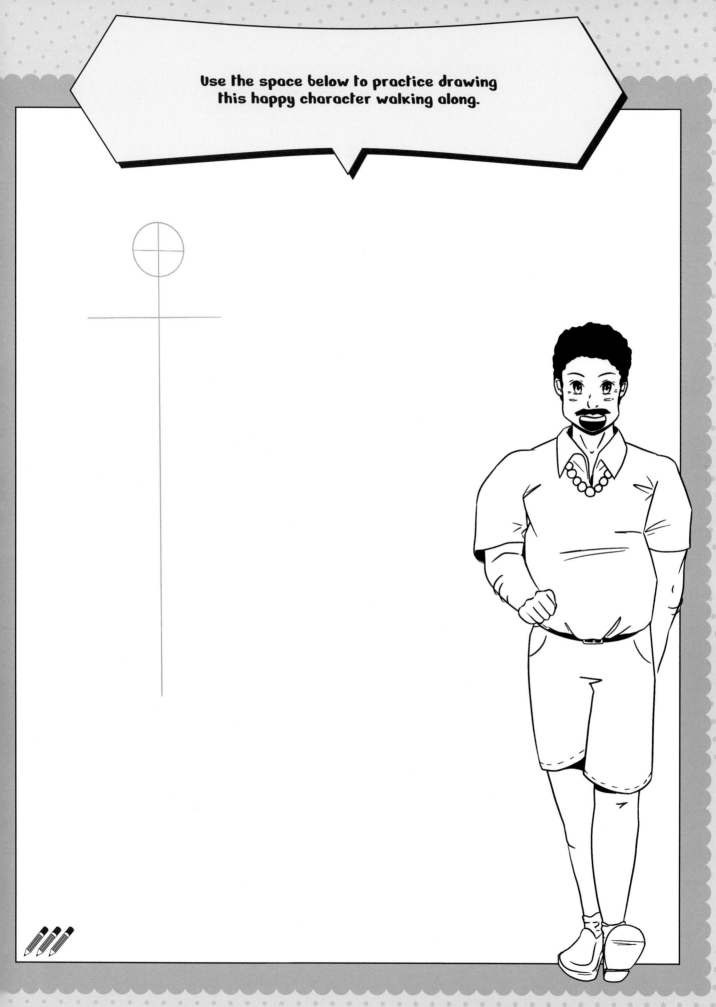

Dynamic Poses: Walking

This next character is seen from a three-quarter view, using a walker for support.

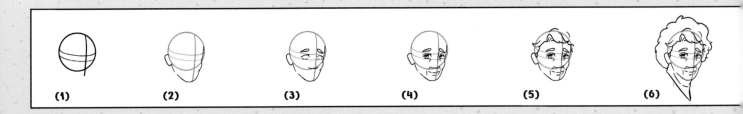

(1) (2) (3) (4) (5) (6)

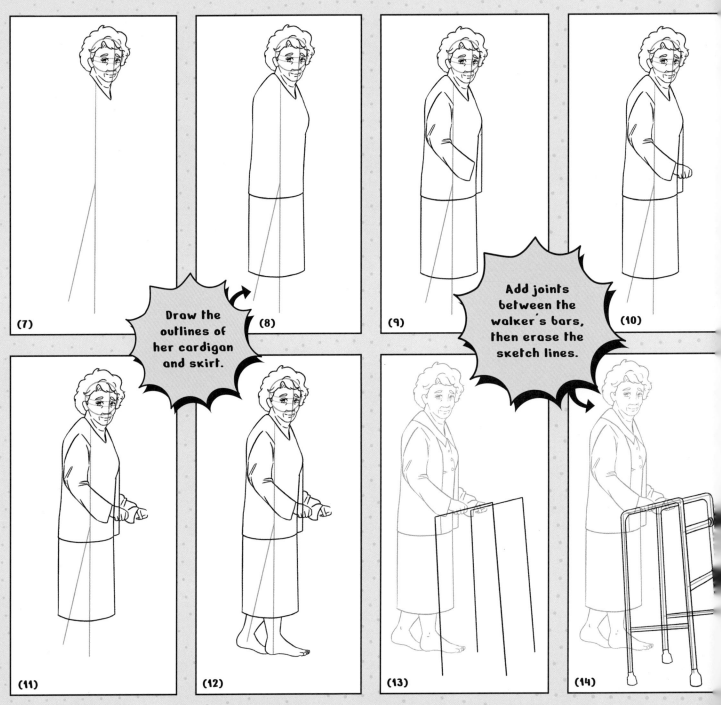

(7)

(8)

Draw the outlines of her cardigan and skirt.

(9)

(10)

Add joints between the walker's bars, then erase the sketch lines.

(11)

(12)

(13)

(14)

Follow the tutorial in the space below.

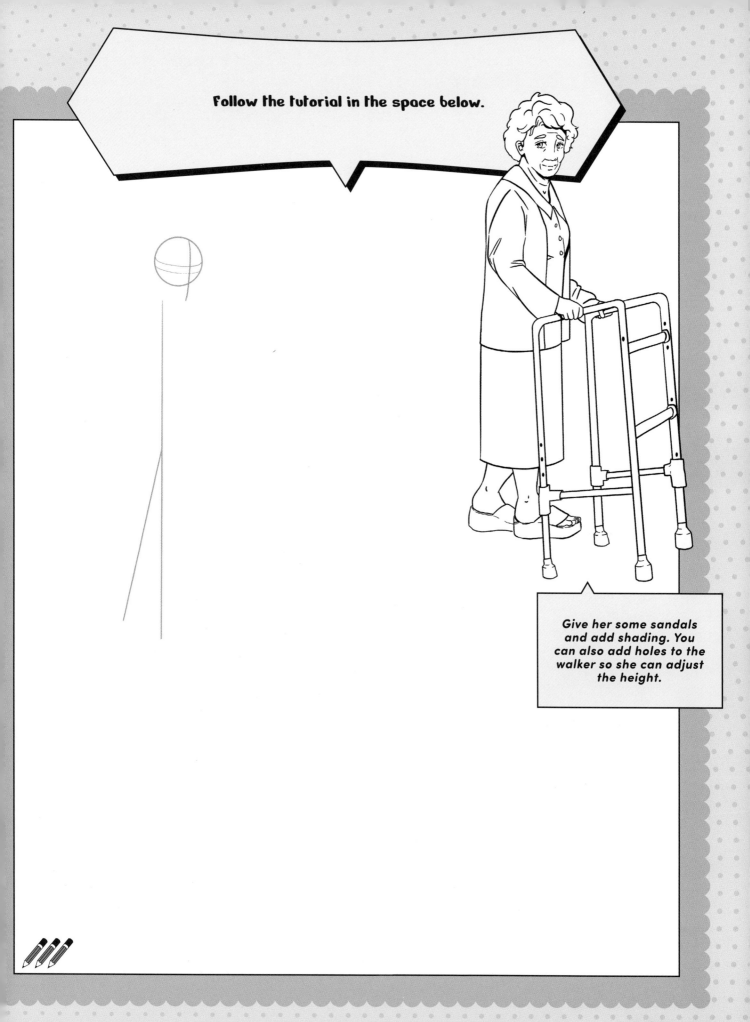

Give her some sandals and add shading. You can also add holes to the walker so she can adjust the height.

Dynamic Poses: Walking

Here is a child walking from a side view. This tutorial shows two variations of the pose: one regular and one hurried.

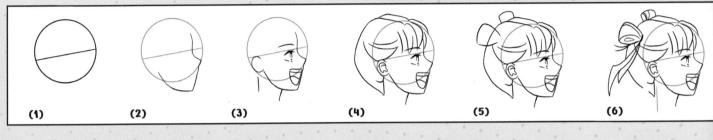

(1) (2) (3) (4) (5) (6)

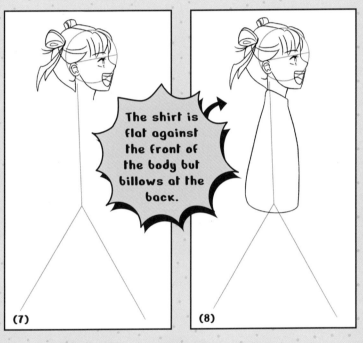

The shirt is flat against the front of the body but billows at the back.

(7) (8)

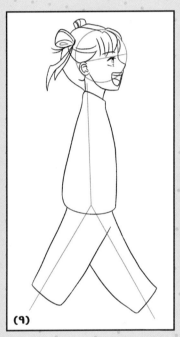

(9)

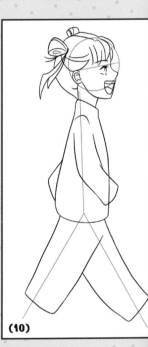

(10)

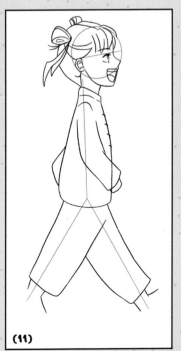

(11)

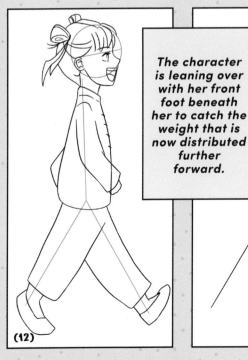

(12)

HURRIED VARIATION

The character is leaning over with her front foot beneath her to catch the weight that is now distributed further forward.

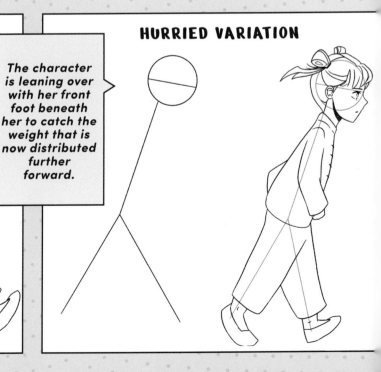

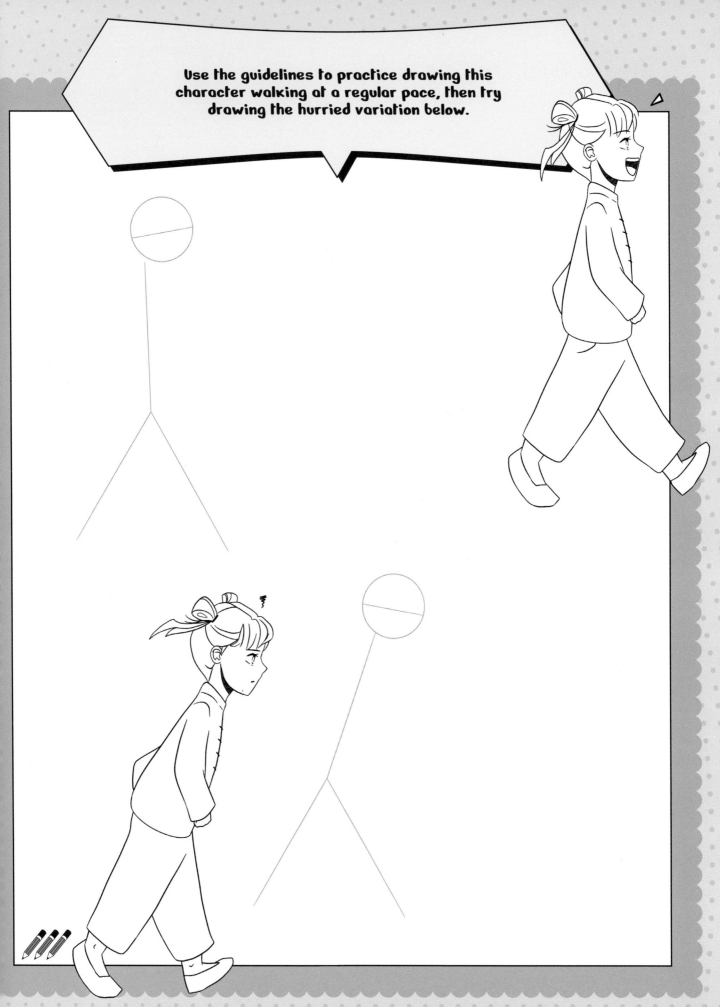

Use the guidelines to practice drawing this character walking at a regular pace, then try drawing the hurried variation below.

Dynamic Poses: Running

Try this front perspective to make a visually interesting pose where your character is running at great speed.

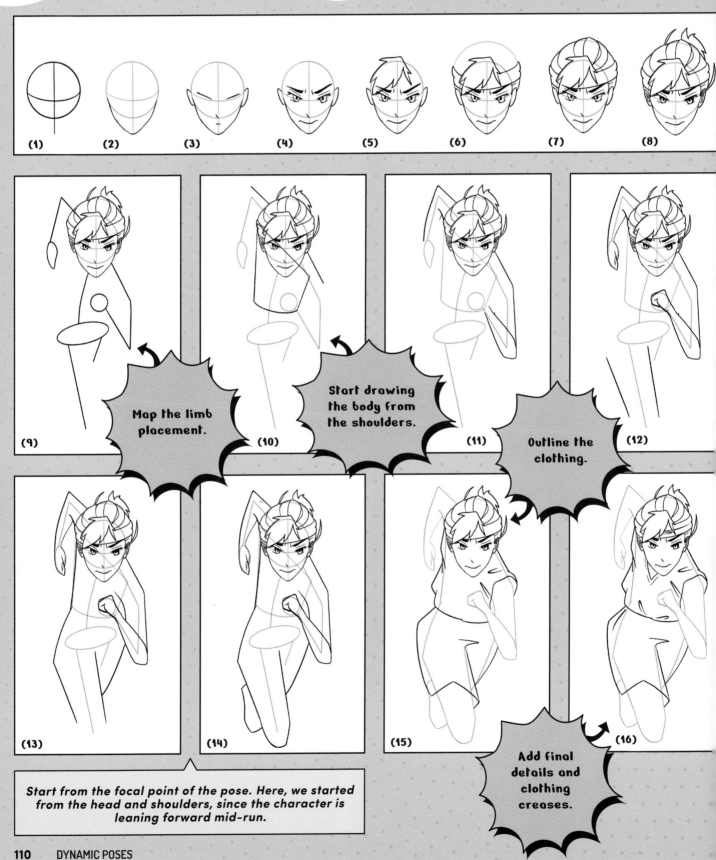

(1) (2) (3) (4) (5) (6) (7) (8)

(9) **Map the limb placement.**

(10) **Start drawing the body from the shoulders.**

(11) **Outline the clothing.**

(12)

(13) (14) (15) (16)

Start from the focal point of the pose. Here, we started from the head and shoulders, since the character is leaning forward mid-run.

Add final details and clothing creases.

Use the "skeleton" outline for more support and the empty space for starting your drawing from scratch.

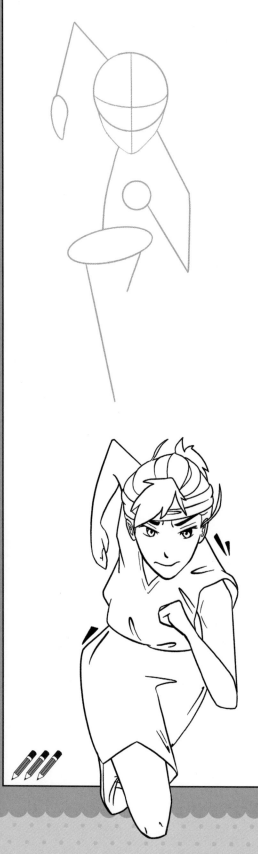

Dynamic Poses: Running

Here is an example of a character running from a side view.

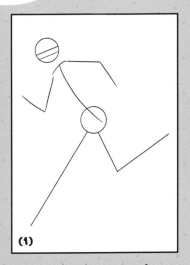

(1)

Map out the placement of the limbs for the pose we are creating.

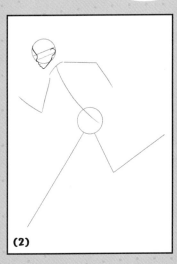

(2)

Outline the face.

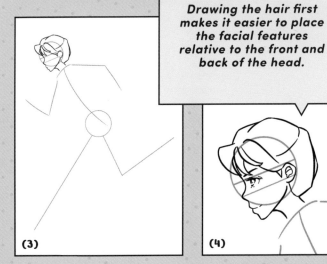

(3)

Draw the hair around the head area.

Drawing the hair first makes it easier to place the facial features relative to the front and back of the head.

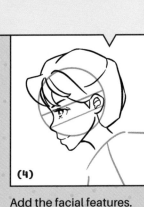

(4)

Add the facial features.

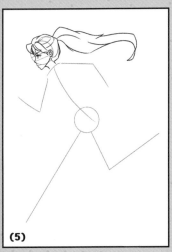

(5)

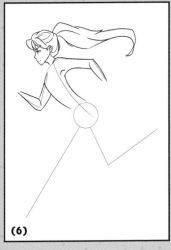

(6)

Add hand details and begin to outline the leg.

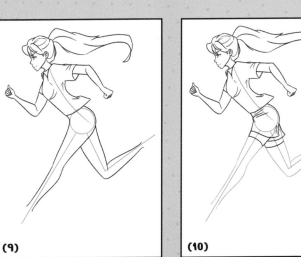

(7)

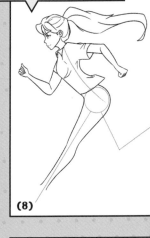

(8)

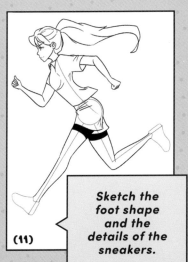

(9)

(10)

(11)

Sketch the foot shape and the details of the sneakers.

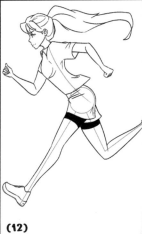

(12)

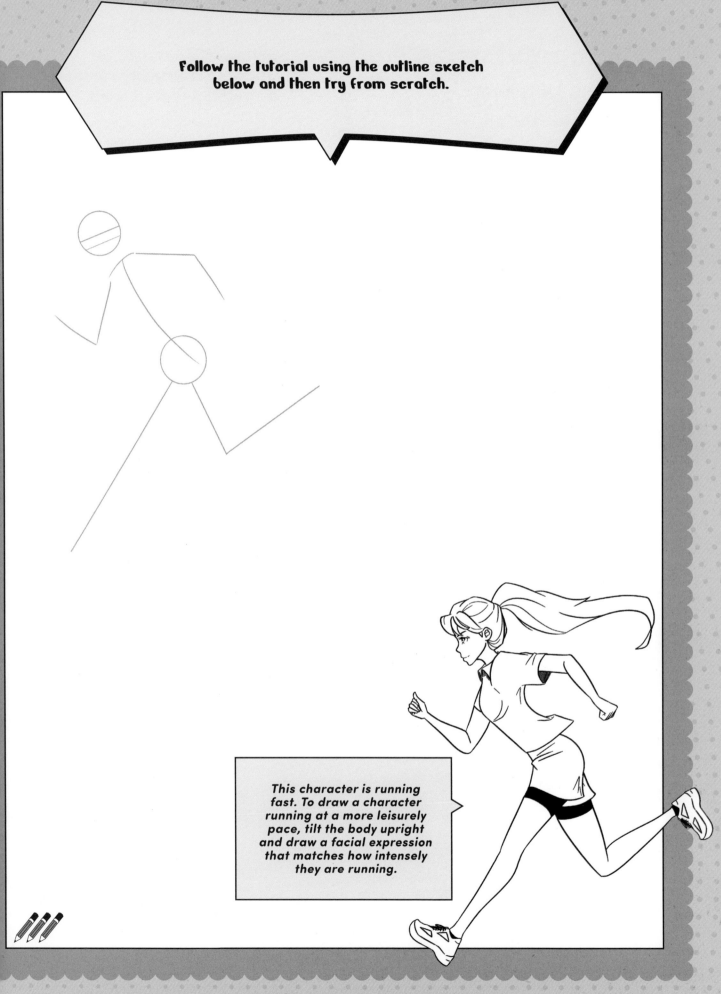

Follow the tutorial using the outline sketch below and then try from scratch.

This character is running fast. To draw a character running at a more leisurely pace, tilt the body upright and draw a facial expression that matches how intensely they are running.

Dynamic Poses: Running

Follow this tutorial for another character running at high speed.

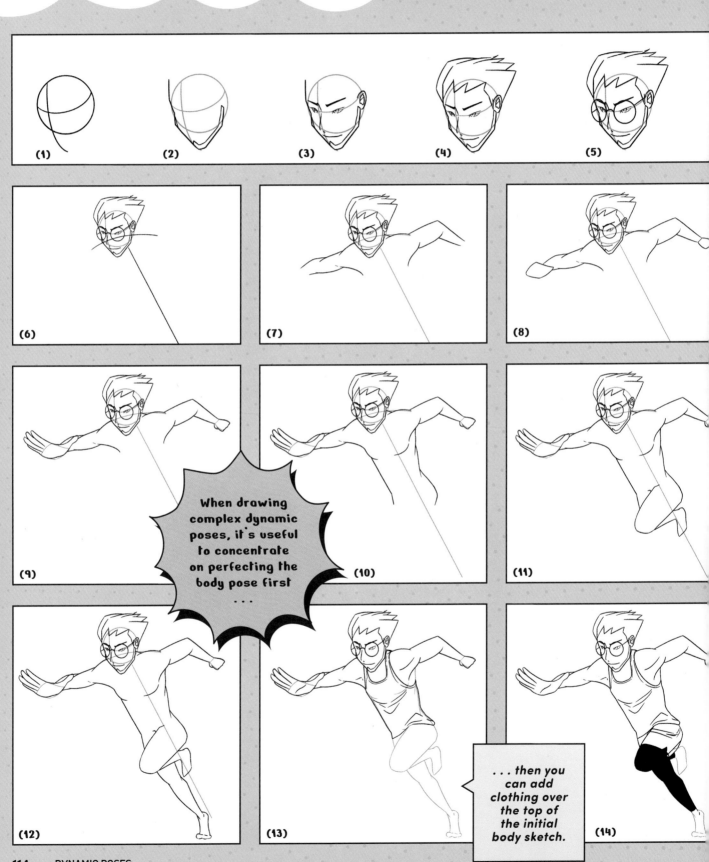

(1) (2) (3) (4) (5)

(6) (7) (8)

(9) (10) (11)

When drawing complex dynamic poses, it's useful to concentrate on perfecting the body pose first . . .

(12) (13) (14)

. . . then you can add clothing over the top of the initial body sketch.

Follow the tutorial in the space below. Add extra running lines or bubble text of exclamations around the character to embellish the drawing further.

Dynamic Poses: Jumping

The next few poses are jump variations. Here, we have a character who is leaping forward over an object.

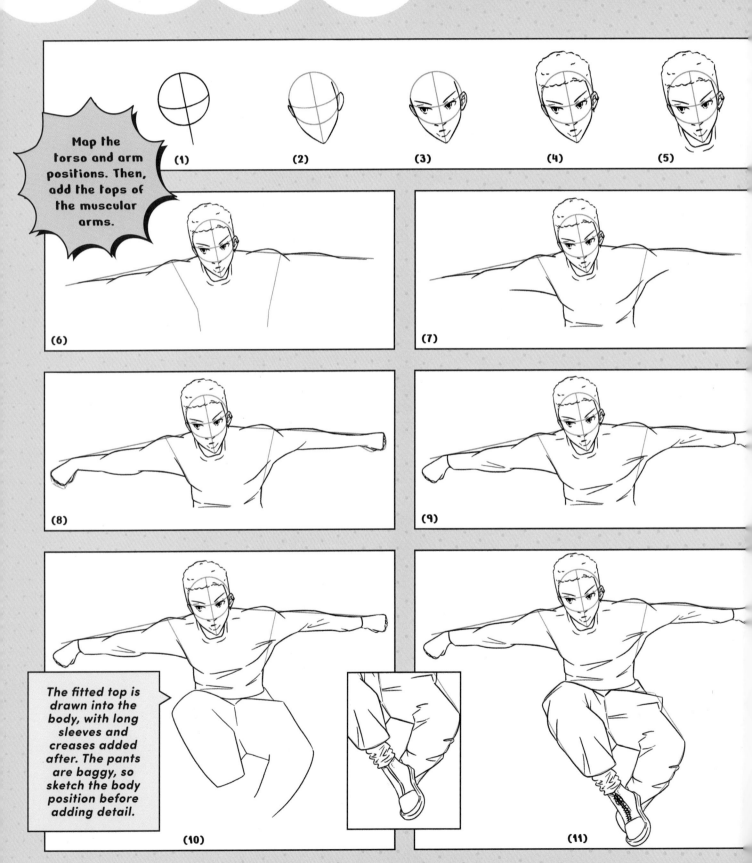

Map the torso and arm positions. Then, add the tops of the muscular arms.

(1) (2) (3) (4) (5)

(6) (7)

(8) (9)

The fitted top is drawn into the body, with long sleeves and creases added after. The pants are baggy, so sketch the body position before adding detail.

(10) (11)

Use the "skeleton" outline for more support and the empty space for starting from scratch.

Give him some jewelry, shading, and embellishments!

Dynamic Poses: Jumping

This second jumping character is leaping over a wall with her legs thrown to one side.

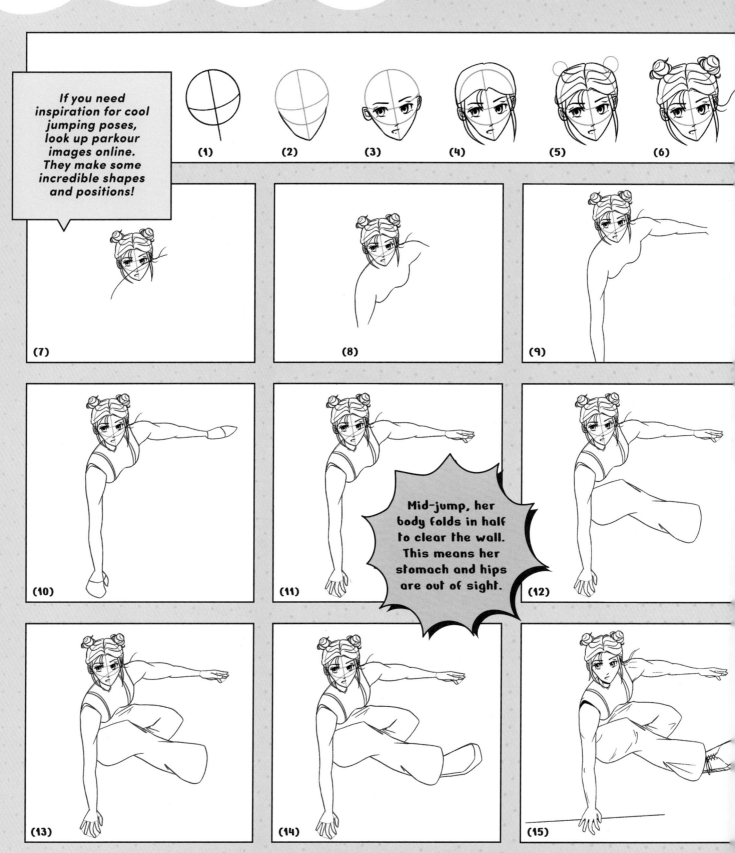

If you need inspiration for cool jumping poses, look up parkour images online. They make some incredible shapes and positions!

(1)

(2)

(3)

(4)

(5)

(6)

(7)

(8)

(9)

(10)

(11)

Mid-jump, her body folds in half to clear the wall. This means her stomach and hips are out of sight.

(12)

(13)

(14)

(15)

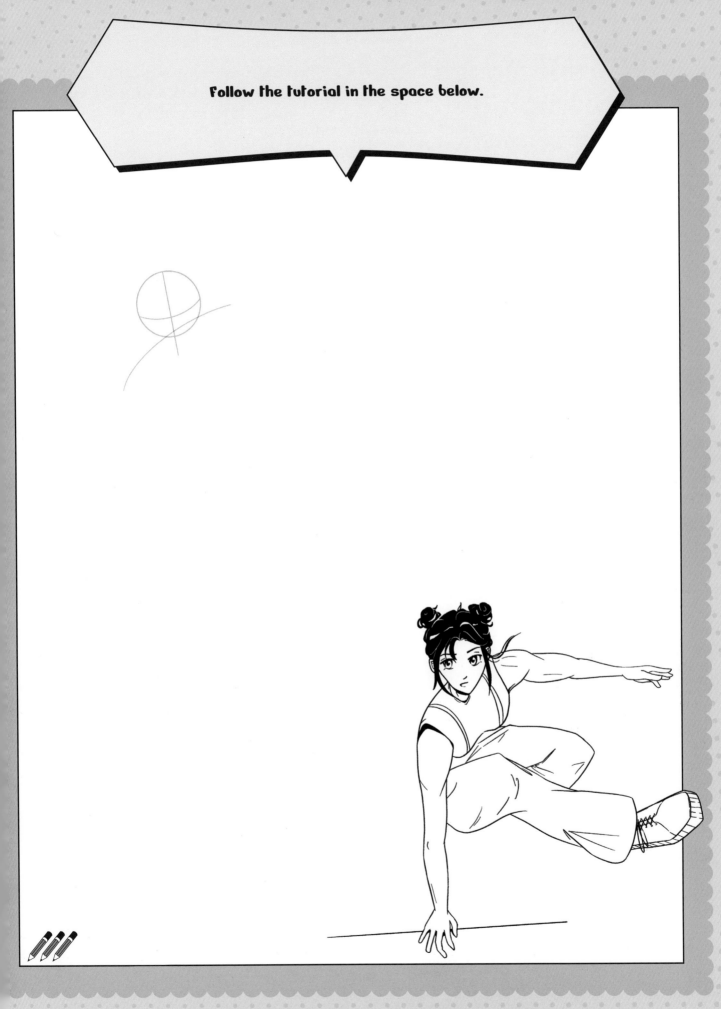

Dynamic Poses: Jumping

The final jumping character is a magical girl doing a "floaty" jump into the air.

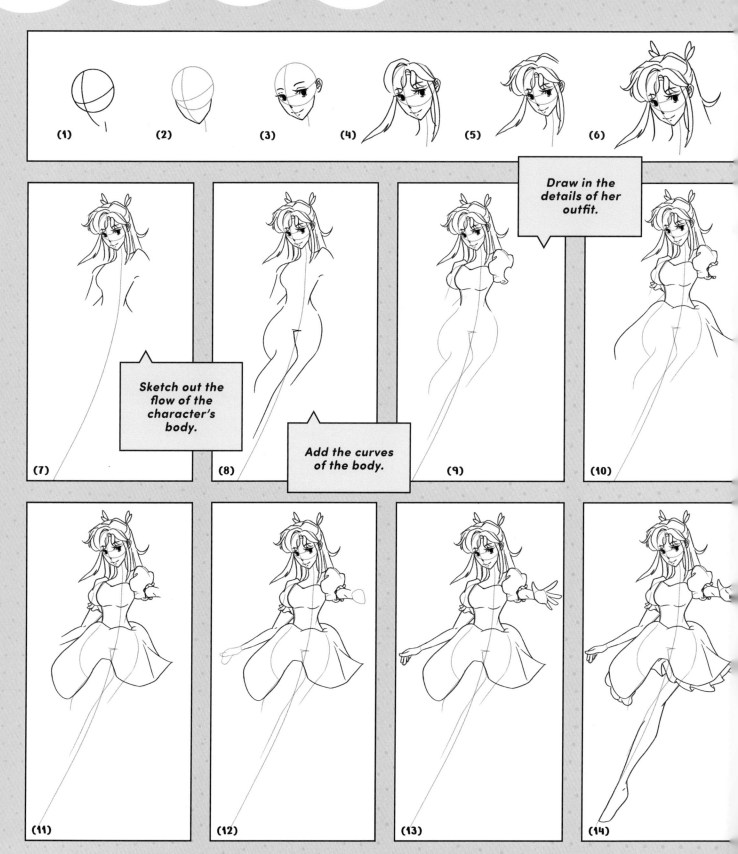

(1)

(2)

(3)

(4)

(5)

(6)

Sketch out the flow of the character's body.

(7)

Add the curves of the body.

(8)

Draw in the details of her outfit.

(9)

(10)

(11)

(12)

(13)

(14)

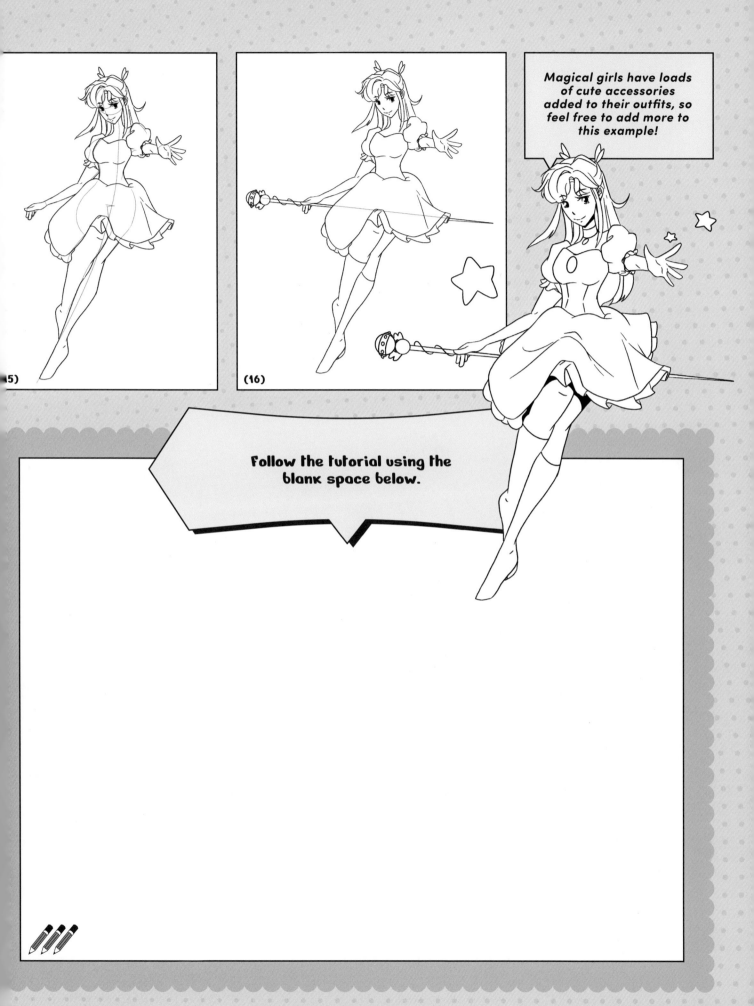

Magical girls have loads of cute accessories added to their outfits, so feel free to add more to this example!

(5)

(16)

Follow the tutorial using the blank space below.

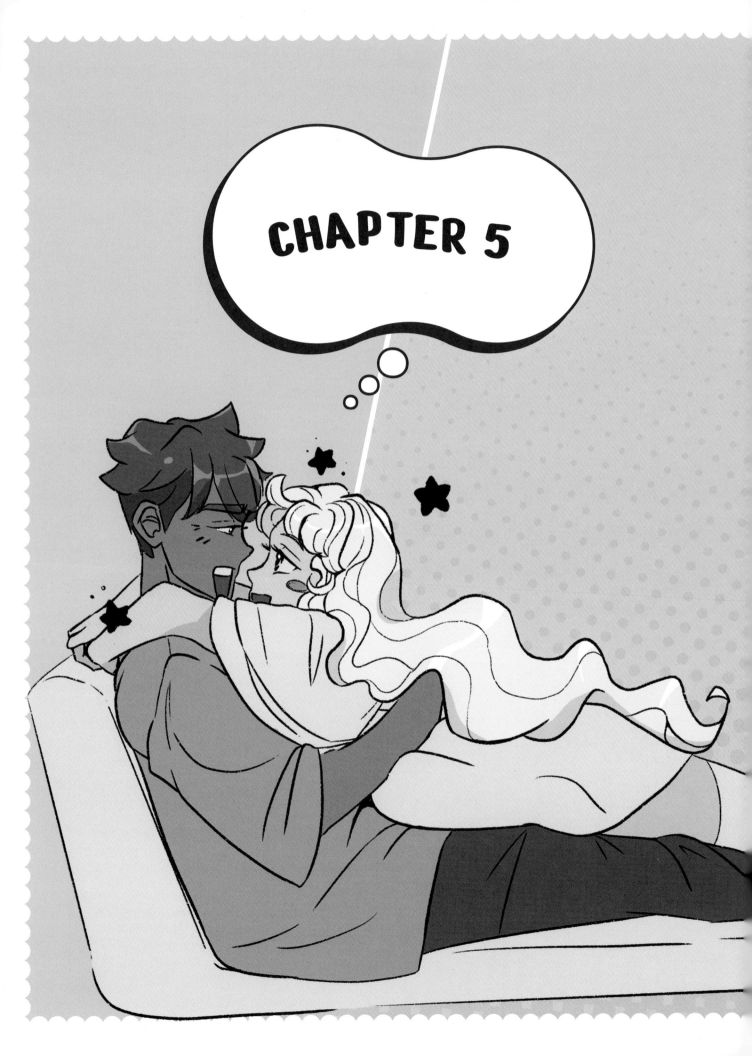

Put It All Together!

This chapter uses features from all the other chapters and gives you the chance to draw your own characters.

There are also some example characters that you can copy to practice your artistic skills. It's time to get creative and have some fun using everything you have learned!

Step by Step: Basketball Player

Before diving into creating your own characters, here are a series of example characters to practice drawing or to refer to when creating your own.

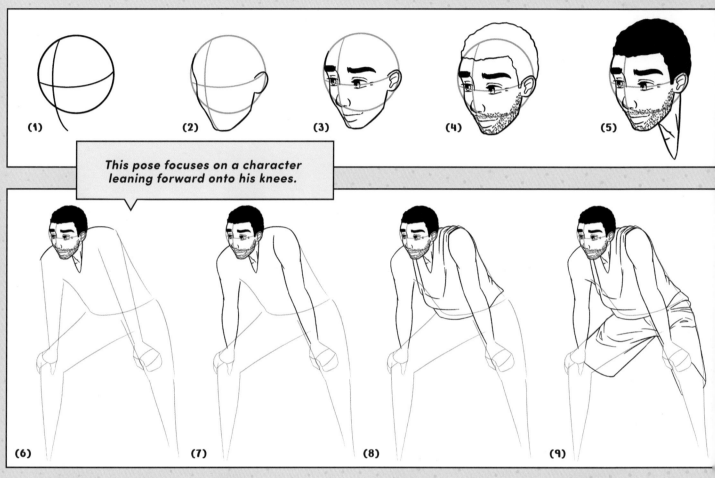

(1) (2) (3) (4) (5)

This pose focuses on a character leaning forward onto his knees.

(6) (7) (8) (9)

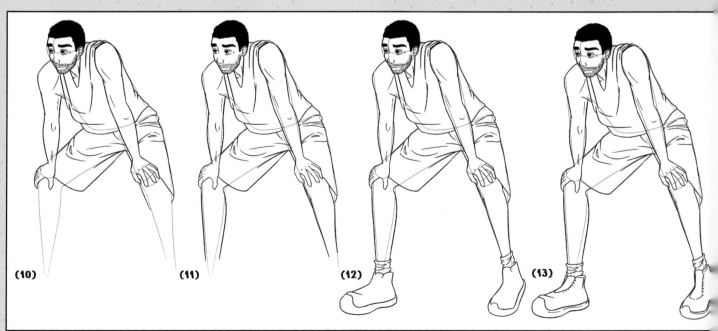

(10) (11) (12) (13)

Follow the tutorial in the space below.

When leaning forward, each body part placement is reliant on another part of the body. The hands are on the knees, but where are the knees in this position? In this example, the entire body is roughly mapped out ahead of the main sketch to make this easier to determine.

Step by Step: Wheelchair

This character has a wheelchair, so first we'll look at how to draw the wheelchair from a three-quarter view. Then we'll add in the sitting character.

First, let's map out the key shapes. Draw the base shapes for the back and seat of the wheelchair.

Add dimension to the basic chair shapes. Then add the handles.

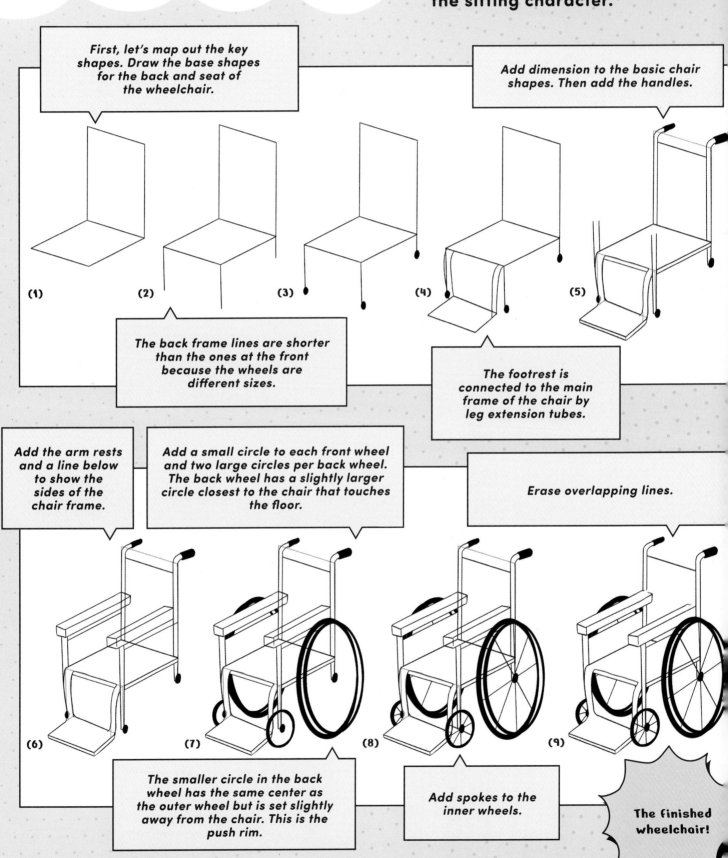

(1)

(2)

(3)

(4)

(5)

The back frame lines are shorter than the ones at the front because the wheels are different sizes.

The footrest is connected to the main frame of the chair by leg extension tubes.

Add the arm rests and a line below to show the sides of the chair frame.

Add a small circle to each front wheel and two large circles per back wheel. The back wheel has a slightly larger circle closest to the chair that touches the floor.

Erase overlapping lines.

(6)

(7)

(8)

(9)

The smaller circle in the back wheel has the same center as the outer wheel but is set slightly away from the chair. This is the push rim.

Add spokes to the inner wheels.

The Finished wheelchair!

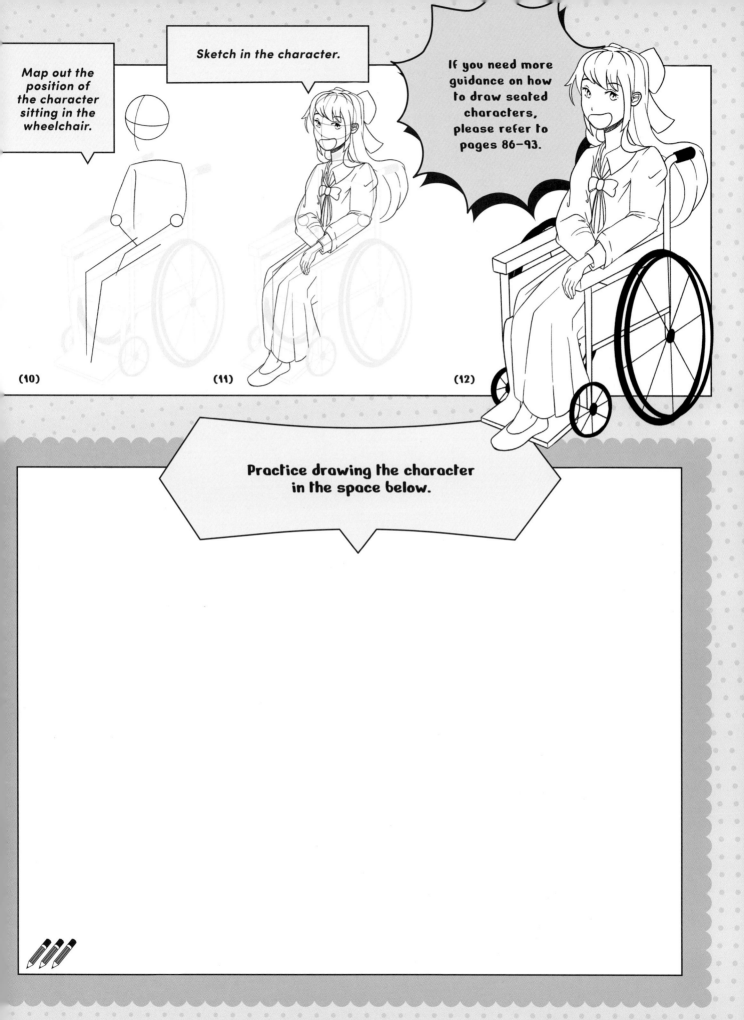

Map out the position of the character sitting in the wheelchair.

Sketch in the character.

If you need more guidance on how to draw seated characters, please refer to pages 86–93.

(10)

(11)

(12)

Practice drawing the character in the space below.

Step by Step: Chibi Character

This tutorial shows you how to draw a chibi character.

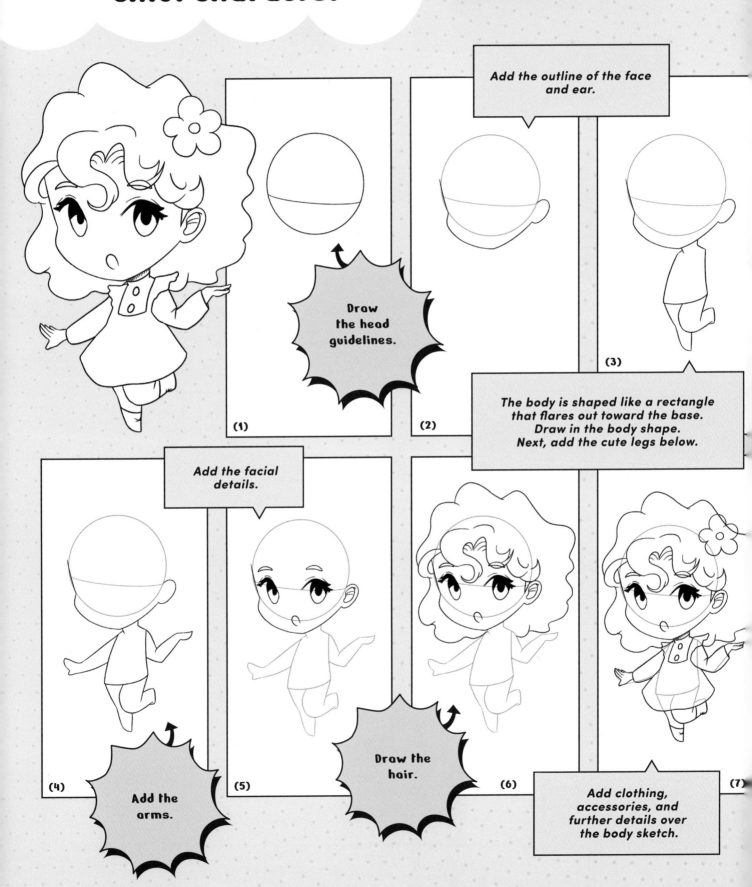

Add the outline of the face and ear.

Draw the head guidelines.

The body is shaped like a rectangle that flares out toward the base. Draw in the body shape. Next, add the cute legs below.

(1)

(2)

(3)

Add the facial details.

Add the arms.

Draw the hair.

Add clothing, accessories, and further details over the body sketch.

(4)

(5)

(6)

(7)

Follow this tutorial using the head guideline below,
then try drawing unguided in the remaining space.
See pages 38–39 for the chibi proportions tutorial.

Put It All Together: Example Characters

Use these characters as references to practice drawing manga characters in a variety of poses.

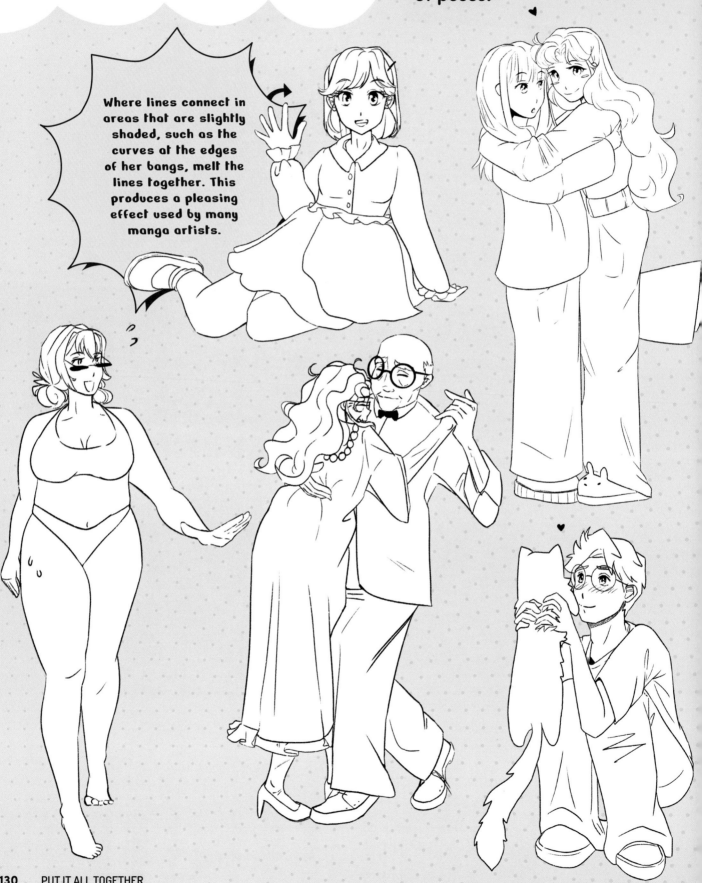

Where lines connect in areas that are slightly shaded, such as the curves at the edges of her bangs, melt the lines together. This produces a pleasing effect used by many manga artists.

Use the space below to recreate
any of these characters.

Put It All Together: Example Characters

Recreate these characters to practice your manga drawing skills. You can copy them exactly or adapt their poses.

Add small embellishments like stars, extra blush, hearts, or, as seen in the beach girl example on the previous page, beads of sweat.

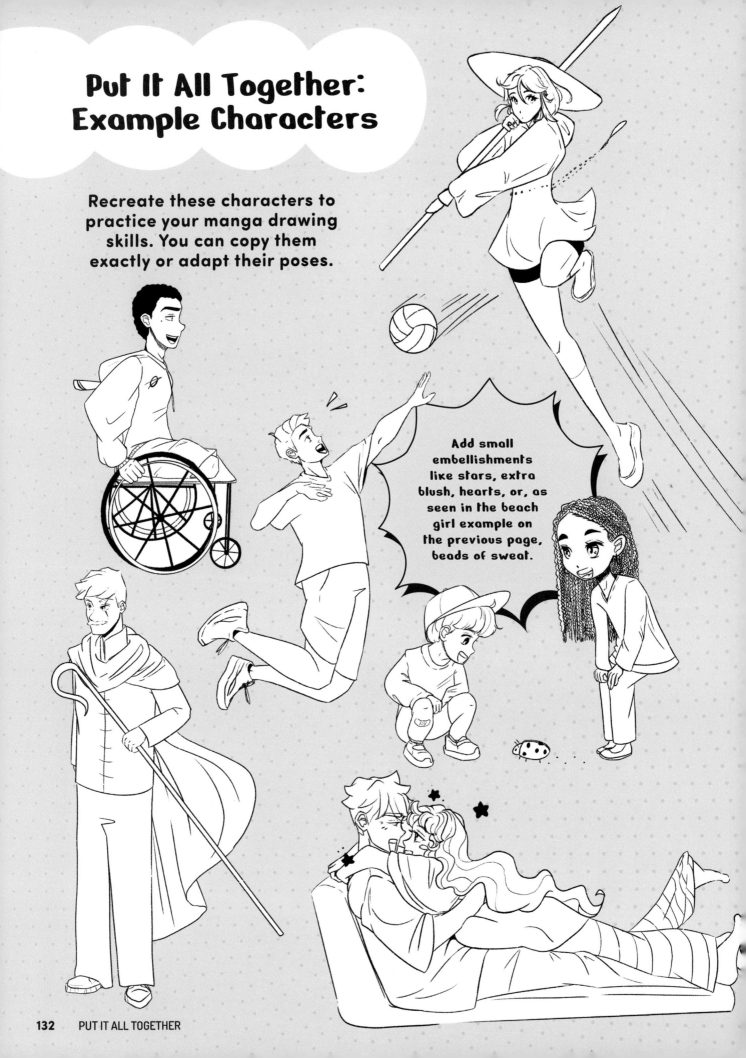

Use the space below to recreate
any of the characters provided.

Put It All Together: Example Chibi Characters

Use these characters as references to practice drawing chibis in a variety of poses.

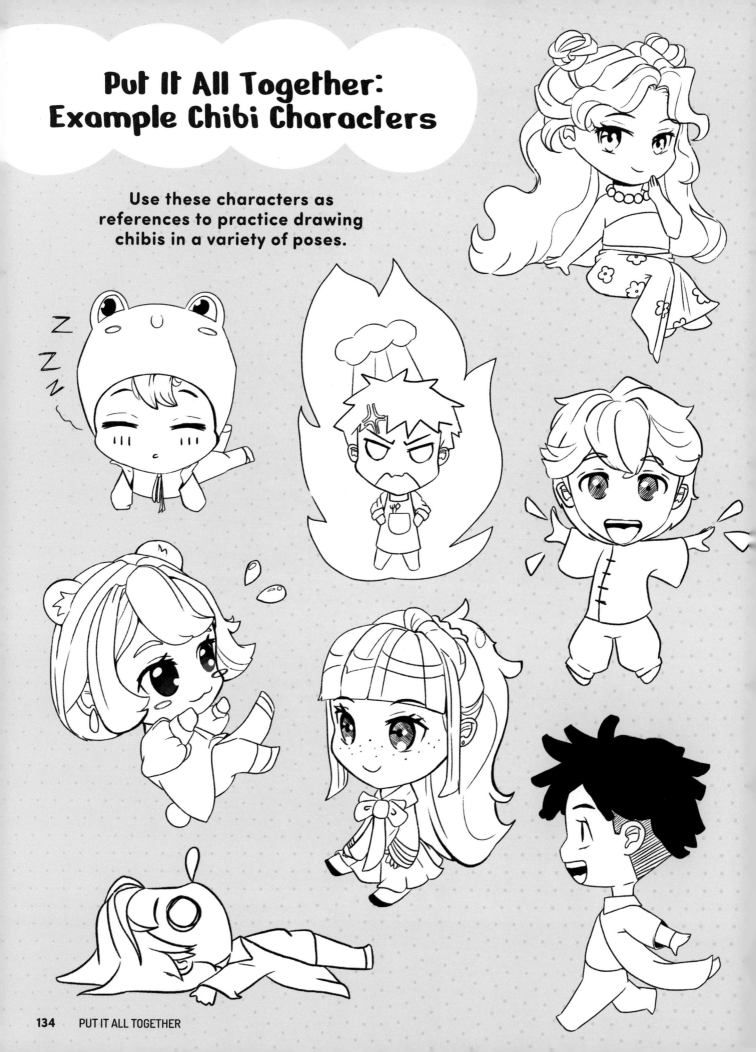

Use the space below to recreate any of the example chibi characters. Feel free to switch up any of the character design details or poses!

Try It Yourself!

A popular exercise for artists is coming up with their own original character, also known as an "OC." Use this space to imagine and draw your own OC.

TIP FOR CREATIVE BLOCK!

Create a vision board using pictures of people, aesthetics, outfits, or anything else that represents a vibe you would like your character to reflect. Use these to help you come up with a character design.

Try It Yourself!

Draw your OC from different angles. This is called a Character Design Sheet. It will help you visualize how your OC looks from all views, making it easier to draw the character!

Try It Yourself!

Draw your OC in a static pose, such as sleeping or sitting. The way your character does these things can tell the viewer a lot about the personality of your OC.

Remember, this space is yours. You can draw more than one pose if you like.

Try It Yourself!

Draw your OC in one or more dynamic poses. How do they run? Do they walk with a spring in their step? Do they exude confidence or joy?

How might you adapt a dynamic pose to show your character feeling different emotions? Practice drawing happy, sad, or angry walks.

Try It Yourself!

Design some other characters who might know your OC.
These could be friends, family, sidekicks, enemies, or simply
a background character who lives in the same world.

Try It Yourself!

Draw your OC interacting with the other characters you designed on the previous page. This could be one big scene or a series of scenes that tell a story.

Index

Acknowledgments

Ella

The biggest thank you to Ella, Martina, and everyone at Quarto who made this the most enjoyable opportunity and were so kind. I am even prouder with how this second book has turned out.

Thank you to all my commission customers who have supported me in my journey, and to my social media followers for giving me confidence in my art.

Thank you to my family and friends for always cheering me on. Special thanks to Louis for being my biggest cheerleader, always supporting me with your words and delicious food so I can keep working hard.

Martina